WATERCOLOR BASICS

An Artist's Guide
to
Mastering the Medium

SUE SAREEN

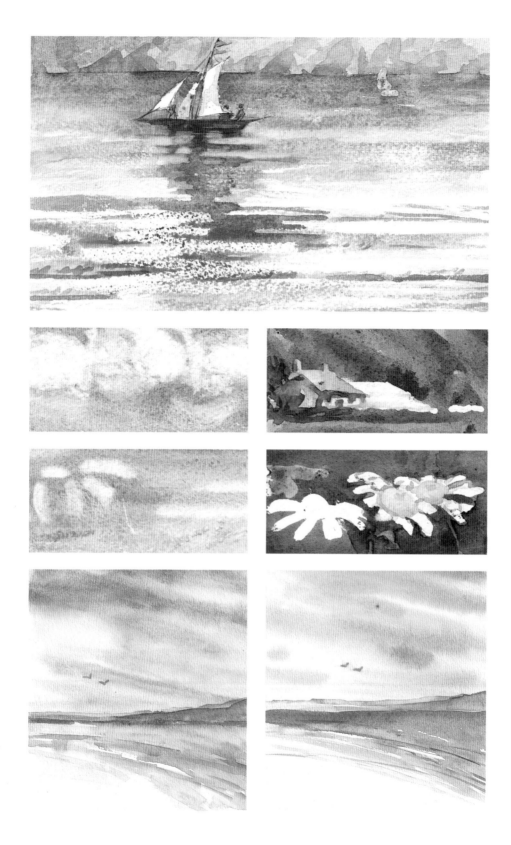

WATERCOLOR BASICS

An Artist's Guide

to

Mastering the Medium

SUE SAREEN

Watson-Guptill Publications/New York

ACKNOWLEDGEMENTS

I wish to thank in particular my partner, William, whose constant support and critical eye helped in the writing of this book. Also my children, who have been amazingly understanding and tolerant, and my sister Helen and her partner, Pat, for providing an American viewpoint. Thanks also to all my students, whose continual enthusiasm, curiosity and interest made the book a very worthwhile project.

PUBLISHER'S ACKNOWLEDGEMENTS

The publishers wish gratefully to acknowledge Daler-Rowney, 3K Project Art and Tollit & Harvey Ltd for their support in lending art materials for photography.

First published in the United States in 1998
by Watson-Guptill Publications,
a division of BPI Communications, Inc.,
1515 Broadway, New York, NY 10036

Library of Congress
Catalog Card Number: 98-85572

ISBN 0-8230-2711-2

First published in the United Kingdom
in 1997
by B T Batsford Ltd
583 Fulham Road
London SW6 5BY

Printed in Hong Kong

First printing, 1997

1 2 3 4 5 6 7 8 9/06 05 04 03 02 01 00 99 98

Contents

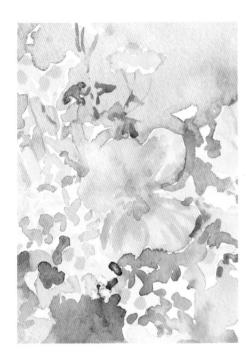

Introduction 6

MATERIALS 8

TECHNIQUES 12

COLOUR AND TONE 20

SKIES 32

TREES AND SHRUBS 38

BUILDINGS 46

WATER 54

FLOWERS 62

STILL LIFE 80

Conclusion 92

Index 94

List of suppliers 96

INTRODUCTION

Watercolour is one of the most enjoyable, versatile and creative of painting media. It is unpredictable, and the challenge to make it work for you will result in continual excitement and stimulation. This is true for an artist at any level, whether he or she is a professional or an amateur who simply paints for fun.

In this most attractive form of painting, water is used as a means to transfer pigment to paper. This allows colours to run into each other, often leading to wonderfully vital mixtures or stunning juxtapositions. Similarly, transparent glazes may be overlaid on top of one another to create unexpected and beautiful colour effects. This delightful combination of process and skill is surely one of the most attractive aspects of working in watercolour.

Another positive attribute of the medium is that it involves the minimum of painting paraphernalia. This makes it relatively inexpensive, and you can always expand your repertoire of paints and papers as you need them. The equipment is also easy to transport and needs very little in the way of storage space, making watercolour painting accessible to everyone.

This book aims to guide you through all the basics of working in watercolour. Giving straightforward explanations and using clear demonstrations and exercises throughout, it will help you to master the essential techniques and provide insights into many of the fundamental principles involved. As you become increasingly familiar and confident with the different techniques, you will discover – as have so many others – the lasting pleasure of painting in watercolour.

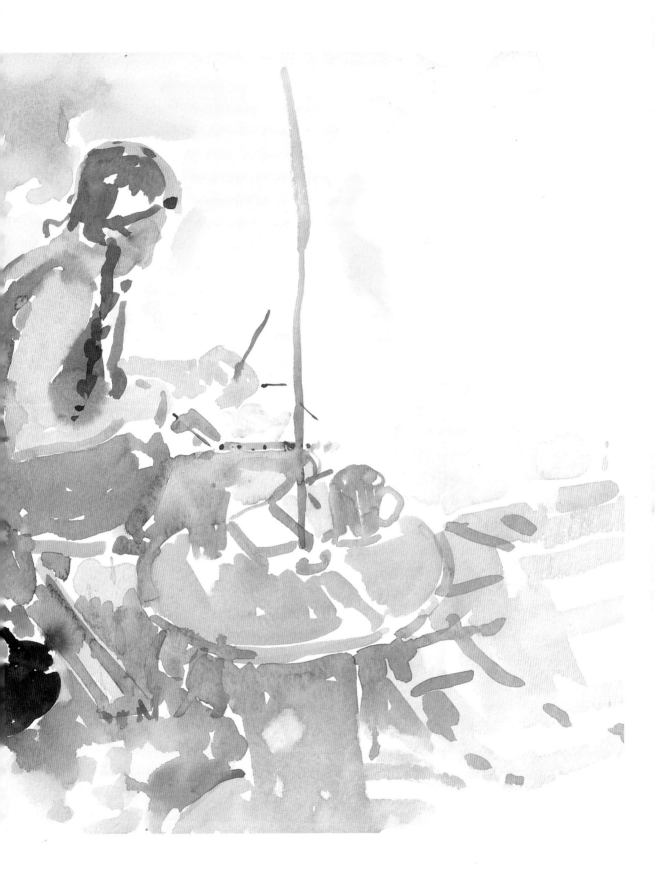

Materials

A multitude of materials is now available for watercolour artists, but you will only need a small selection at first. Choosing a great array of cheaper materials rather than a few more costly ones may seem a better option, but good-quality materials will last considerably longer – making them better value in the long term – and will also help you to achieve more successful results.

PAINTS

Watercolour paints are available in students' and artists' quality. The former are adequate to get you started, but can be difficult to work up and often produce disappointingly thin washes. The latter are more expensive but respond quickly to the brush, and have the edge in richness of pigment and permanency.

It is worth checking the permanence of any colour, as this may be a deciding factor in which kind you choose. Most watercolour paints have a 'star' rating with the numbers increasing along with the permanency. For example, a colour with one star is described as 'fugitive' or non-permanent, while one with four stars is permanent.

Choosing colours

Landscape painters often use a restricted palette, with earthy colours and those that can create interesting textures. Flower painters need a wider range, including some of the more exotic and transparent hues.

Start with a limited number of colours, gradually adding to these as you gain more experience. Most ready-assembled boxes for beginners will contain a good range of colours to get you started. You may prefer to buy your colours separately, and I would recommend the following range:

Reds
• Alizarin crimson
• Cadmium red
• Light red
• Burnt sienna
• Sepia

Yellows
• Cadmium yellow
• Yellow ochre
• Raw sienna
• Lemon yellow

Blues
• Ultramarine
• Cobalt blue
• Cerulean blue
• Prussian blue (or Winsor blue)
• Payne's grey

Flower painters will need to add permanent rose, Winsor purple and Hooker's green (see page 64).

White is very rarely used in watercolour painting, as when added to a colour it makes it opaque – normally the white of the paper stands for white areas, and colours are lightened by diluting with water or by adding a lighter colour. In tonal sketches, opaque white paint can be used to pick out highlights (see page 25).

Tubes or pans?

Watercolour paints are available in tubes or pans. Landscape artists, with their more restricted palette, often prefer to use tubes – they can squeeze out some moist paint on to the palette and, being very familiar with the colours, have no problems in deciding

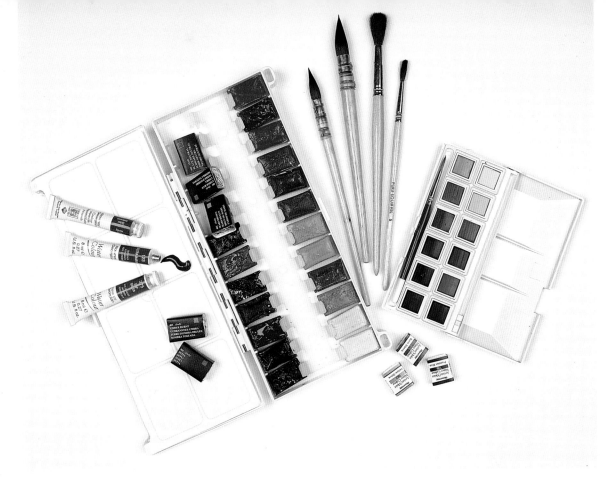

Range of half pans, full pans and tubes in artists' quality (left) and students' quality (right).

which to use. Tube colours are especially useful for large-scale work. However, if the paint dries in the tube it will be wasted (some artists split open tubes and use the dried paint as a 'pan', but the paint does tend to crumble, making the effort hardly worthwhile). Flower painters need to see their colours before deciding which to use, generally making pans the preferred choice.

Half and full pans are available. My own preference is for full pans as, although half pans seem more economical, it can be awkward to get brushes into them when a large amount of paint is needed for washes. I suggest that you start with a range of full pans which will be suitable for both landscape and flower paintings, and, as you use them, you can refill them from tubes.

BRUSHES

Brushes can be very expensive, but you could start with those made of mixed nylon and hair,

which are good value for money. I would not recommend pure nylon brushes, as they are rather inflexible and do not hold a sufficient amount of water. Sable or squirrel brushes are superior, but not cheap.

Which brushes to choose?

Well-made brushes with good points can each be used for a range of tasks, from applying washes to putting in small details. Start with just three brushes: a large, round size 12, a size 8 and a size 2. However, note that these are English sizes – other brushes tend to be sized in the opposite way, with larger numbers denoting smaller brushes. For instance, my largest brush is a French size 4 – roughly the equivalent of an English size 12. In time, you may like to add to your three brushes a ½-inch flat and a rigger size 2 brush. A flat brush can be used to produce two different effects (see page 15), while the long hairs of a rigger brush make it ideal for lightly 'flicking in' delicate details such as tree twigs (see page 39).

I also have a small, very worn hog's-hair (bristle) brush, which I find ideal when used with clean water for softening edges or for gently removing paint without damaging the paper.

Caring for your brushes

It really does pay to look after your brushes. Keep some jam-jars filled with water handy for cleaning them, and leave upright to dry. Never leave brushes standing in water for long periods.

To protect brushes when applying masking fluid, see the Tip on page 16.

PAPER

Although many useful watercolour pads and sketchbooks are available, it is more economical to buy large sheets and cut them up to the required size.

The most common size for loose sheets is 56 x 76 cm (22 x 30 in). These vary in hue from bright white to soft creams; a range of tinted papers is also available.

Paper surfaces

There are three surfaces: Rough, Hot-pressed and Not. It is worth experimenting with these, as they take the paint differently. Rough paper suits an 'open' style, and emphasizes any grainy effects by holding the colour in the 'wells' in the paper. Hot-pressed paper is smooth and close-grained so that every brushmark tends to show, but subtle and delicate washes may be achieved. Not paper (meaning 'not hot-pressed', and also known as cold-pressed) is the most widely used type, and has a 'tooth', or slightly textured surface that allows washes to adhere consistently to the paper.

Weights of paper

Watercolour papers come in the following weights:
• 190 gsm (90 lb) • 300 gsm (140 lb)
• 425 gsm (200 lb) • 640 gsm (300 lb)
• 850 gsm (400 lb)

I advise choosing from the heavier papers, which are less likely to cockle, or wrinkle, when wet (see below). I rarely paint on paper lighter than 300 gsm (140 lb).

Stretching paper

Some artists stretch their paper before use as a precaution against cockling. I find this too time-consuming, and prefer lightly to attach the paper to my drawing board at the corners with masking tape. It can then expand and contract at will. If you do wish to stretch your paper, you will need to wet it on both sides and stick it to the board with wet, gummed tape, running this around all the edges. The paper will dry taut and returns to this state even after a number of washes.

OTHER EQUIPMENT

In addition to paints, brushes and paper, there are a number of other items, some of which are necessary and others which are simply designed to make things easier.

A palette

There are many sophisticated palettes on the market, but I simply use a large enamel plate, which I take care to keep clean (I find a palette with wells a hindrance, and a flat surface much better).

A drawing board

Although I only ever attach my paper to a board at the corners, I find the board essential. Your board must be light in weight, as you will often need to pick it up to encourage wet paint to run and diffuse on the paper. Thin plywood is ideal. A large sheet of watercolour paper cut into quarters makes four sheets measuring 38 x 28 cm (15 x 11 in), so for most purposes a board slightly larger than this will be adequate.

Pencils

For general sketching prior to painting, I recommend pencils in the H to HB range, as these are fairly hard. Softer pencils tend

to 'dirty' the paper and can get into the paint. Water-soluble graphite pencils can also be useful for sketching (see page 25).

Pens

Work with a pen is often combined with watercolour (see page 14). The most accessible types of pen are known as drawing pens, although you could use an ordinary fountain pen. Indian ink is ideal for drawing pens and, being permanent, will not run when wetted. However, it should not be used in a fountain pen as it will clog it up.

Masking fluid

This is painted on to the paper to protect an area from subsequent washes. After painting, it is easily removed by rubbing with a finger to reveal the white paper beneath. It can be applied with a brush (see Tip on page 16) or simply dribbled on to the paper.

Soft tissues

I find these essential. They may be used, like a sponge, for removing or softening, and for lightening wet areas by blotting.

They can also be used for blotting to create textures in wet paint.

A sponge

I use a medium-sized, soft sponge. You need not buy an expensive, natural one but it must be soft. A sponge like this is better than a brush for dampening paper, as it easily soaks up any excess water. I also use it with most of the water squeezed out, for removing or softening painted areas.

Outdoor painting equipment

You may require a little extra equipment when painting outside. I carry everything I need in a small rucksack. I also sometimes take a hard-backed, spiral-bound sketchbook for convenience, rather than my board with paper attached. A lightweight fishing stool can be useful for sitting on, or you can always sit on the ground or against a wall with your sketchpad resting on your knee as I do.

An easel will be cumbersome should you wish to combine your painting with walking, and will really only be necessary if you plan to paint on a large scale.

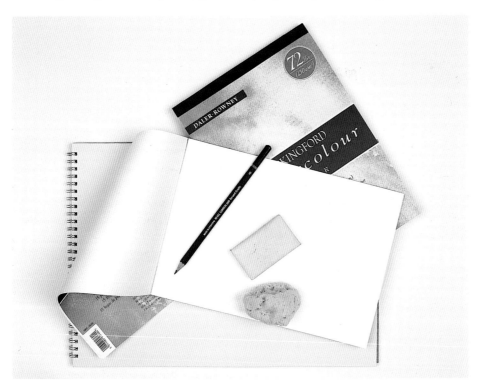

Sponge, putty rubber, HB pencil and a range of watercolour papers.

Techniques

Many techniques can be employed in watercolour painting. All artists have their particular favourites, and part of the fun of the whole process lies in improvising your own. The following are some of the methods that I like to use.

THE WASH

A straightforward wash is very simple. A delicate, transparent wash can be produced by thinning the paint with water (using roughly 30:70 paint to water) and then, using a large brush, working from side to side from top to bottom as seen below.

GLAZING

In this technique, one colour of paint is washed on to the paper and allowed to dry. Another transparent wash is then gently laid on top, to add depth while allowing the first colour to shine through.

The original colours

The glazes

Yellow + pink = orange *Yellow + blue = green*

WET-IN-WET

Wet paint is dropped into wet paint as seen below, so that the colours mix on the paper.

TIPS

- Leave the first wash until it is bone-dry before applying the second.
- Add sufficient water to the subsequent glaze to ensure transparency.

RESIST METHODS

The four examples below show different ways of lightening areas, or of protecting them so that they remain clean and white.

finger and the white area beneath can then be modified if desired as shown in the two illustrations below.

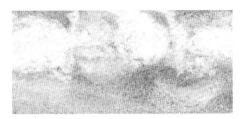

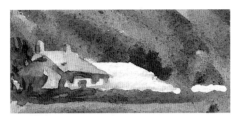

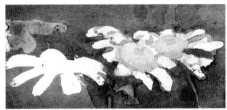

BLOTTING OFF

Two examples of lightening or removing areas of colour are shown above. This can be done by blotting with a soft tissue or sponge, or a hog's-hair (bristle) brush.

MASKING OUT

To keep specific parts of a painting white, masking fluid (see page 11) may be applied to the required areas before any washes are brushed on. When the colours are dry, the fluid may be removed by rubbing with a

APPLYING CANDLEWAX

Candlewax can be used as a resist, but is only suitable for broad, coarse textures. Leave in place or cover with an old cloth and melt off the paper with a hot iron.

FINE-GRADE SANDPAPER

The abrasive surface is ideal for suggesting rough textures. In the picture below the sails were masked out and the surface of the water was modified using candlewax, a hog's-hair (bristle) brush and sandpaper.

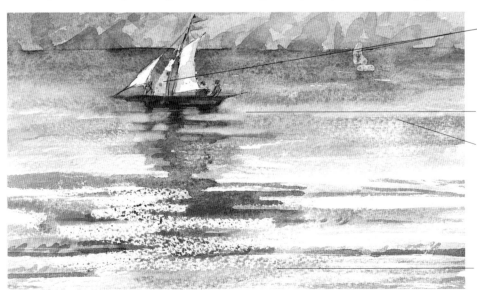

Sails with masking fluid applied

Areas of paint removed with hog's-hair (bristle) brush

Texture created with sandpaper

Effect achieved using candlewax as a resist

TEXTURE

A range of texturing techniques is shown here and combined in the woodland scene below, but you can experiment with different tools, papers and media to create many interesting results of your own.

One of the simplest means of varying textures is to rely on the paint itself. While some paints are smooth, others (such as ultramarine and monestial blue) are grainy.

TIP

If you inadvertently produce blobs while spattering, twist a piece of soft tissue and dip it into the blob to 'suck up' the excess paint.

Ultramarine

Monestial blue

Spattering

In this very basic technique, the hairs of an old toothbrush – loaded with paint – are simply flicked over the paper to create a texture. Try this on dry paper (as here) and then on wet paper for two different results.

Indian ink

Exciting effects can be achieved by dropping Indian ink on to wet paper. The ink will granulate, producing interesting textures.

Pen and ink

This medium is often combined with watercolour. The pen can be used as a drawing tool, with gentle washes of colour, or to put in extra detail as in this picture.

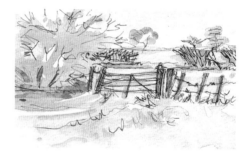

Masking fluid

This can be dribbled on to paper to create haphazard resist marks (the paper is sometimes tinted first).

Trees initially masked out and then modified

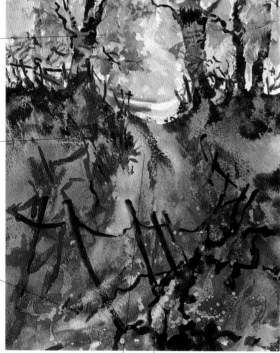

Pen and ink used to pick out details

Texture created with pen and ink

Grainy plants painted in ultramarine, burnt sienna and light red

Surface rubbed with sandpaper

Masking fluid dribbled in foreground

CALLIGRAPHIC BRUSHMARKS

Brushes can make all kinds of marks, depending on how they are used. These marks often help to summarize and convey a 'sense' of the subject being painted. Different types of brush will obviously create different marks and a combination of flowing and angular brush strokes can be particularly effective in certain styles of painting as in the herbaceous border illustration shown at the bottom of this page. Here a variety of calligraphic brushmarks was used to express the different textures and shapes of the garden foliage.

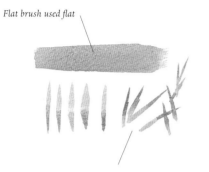

Flat brush used flat

Flat brush used edge-on

Marks made with a pointed brush

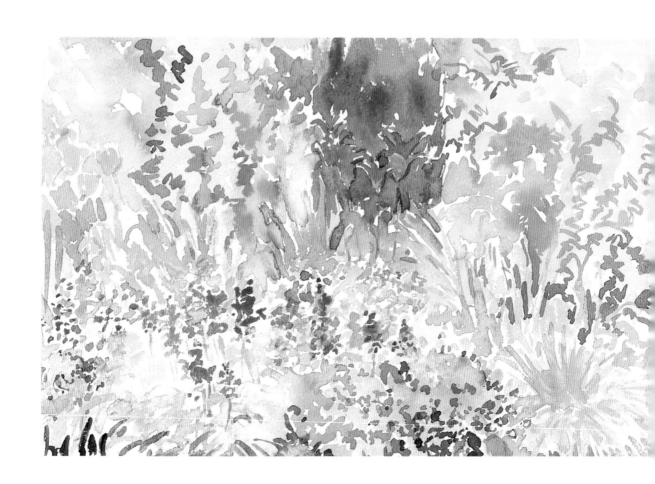

Roll the brush in soap before using it to apply masking fluid. When you have completed the masking, wash the brush in warm water. The masking fluid will then come off easily, without damaging the brush by clogging the hairs.

EXERCISE – basic techniques

This step-by-step exercise incorporates many of the techniques described so far. Working through it will help you understand the varied effects you can achieve in watercolours. Study the finished picture on page 19 before you begin.

COLOURS
- **Red** – burnt sienna
- **Yellow** – yellow ochre, bright cadmium yellow and raw sienna
- **Blues** – cobalt blue and ultramarine

PAPER
Bockingford Not, 300 gsm (140 lb)

BRUSHES
- English sizes 12, 8 and 2

Stage one
1 Lightly draw in a horizon two-thirds down the paper with an HB pencil. Draw in the shapes of the near and far hills and then the grasses in the foreground.

2 Using the fine brush, apply masking fluid along the horizon at the base of the hills – where light would catch on the water – and on the foreground grasses.

3 Sponge the paper lightly with water, to enable it to take the subsequent wash more readily. Using the largest brush and plenty of water, work a wash of raw sienna or yellow ochre (these colours are very similar) over the whole paper.

4 Brush on some bright cadmium yellow where the sun rises behind the hills and shines on the water in the foreground. This paint should be slightly thicker and dryer than the initial wash to avoid 'tide marks'. Do this quickly, working wet-in-wet, so that the colours blend together.

5 Pick up the board and move it about to encourage the paint to disperse gently – you may need to nudge it with a brush. Then leave the paper to dry thoroughly.

Masking fluid used to reserve white paper at horizon and on grasses in foreground

Stage two

1 Dampen the dried paper down to the horizon, working with care so as not to disturb the initial wash.

2 Check that the paper is evenly damp and that there are no dry patches. This is done by tipping up the board and looking at the shine of the wash (any missing patches will appear matt).

3 Using a loaded brush and vigorous movements, boldly sweep ultramarine across the upper area of the sky and add some cobalt blue in the lower part.

4 Quickly tip the board in different directions to encourage the colours to merge, then leave the paper to dry.

5 Paint all the hills – near and far – with a very dilute mixture of burnt sienna and ultramarine (this combination makes grey), then leave the paper to dry.

TIP

Always try to work fast – then leave everything to dry. Fiddling about will only create problems.

Paper tipped in different directions to encourage merging of sky colours

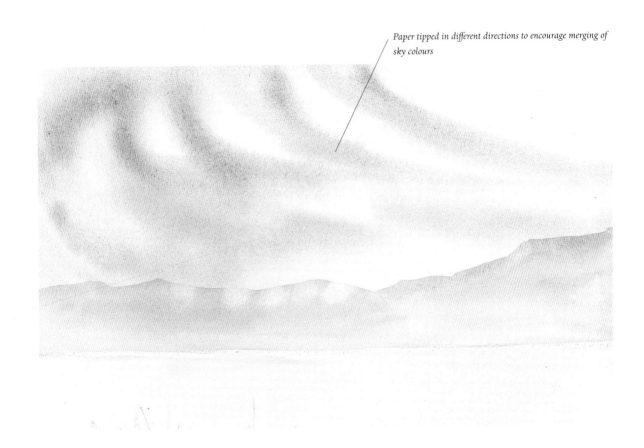

Stage three

1 Paint the middle and foreground hills over the distant hills with a richer mix of the same colour (vary the colour by changing the proportion of burnt sienna to ultramarine) so that they appear darker. When these are dry, paint the foreground hills so that they appear darker still. As there will now be three layers of paint in the area of the foreground hills, take care not to make this last layer too thick and opaque – ideally the earlier layers should actually show through the later ones, exploiting the transparency of watercolour. While still wet, drop pure colour into the paint and tip the board to encourage one colour to run into another. Experiment with gently blotting small areas with soft tissue. This dries and lightens the area, creating interesting textures.

2 Rewet the paper below the horizon line.

3 On the damp paper, with horizontal brushmarks, gently suggest reflections of the hills as mirror images in the water. Leave the paper to dry.

Even darkest tone remains transparent so that previous paint layers show through

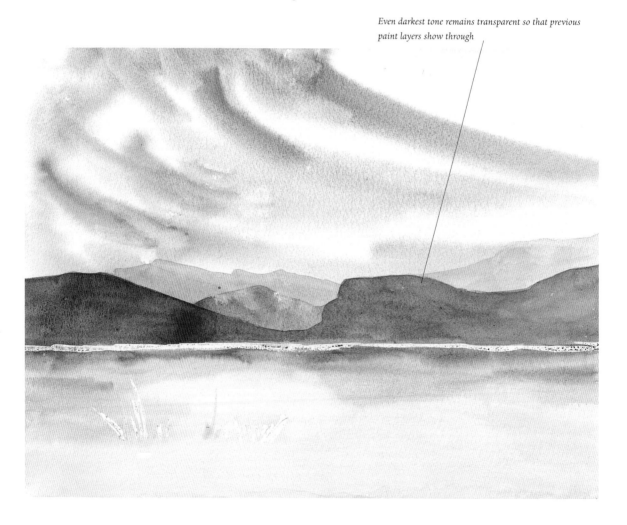

Stage four

1 Rub the masking fluid from the horizon line and foreground grasses with a finger. The white areas of paper that remain will look a little too bright, so tint them with raw sienna or yellow ochre.

2 Paint in the grasses in darker and lighter shades, and draw in the reflections with a brush on the dry paper. These should be hard and precise, in contrast to the soft reflections added in Stage three, when the paper was damp.

3 Create some highlights in the water by rubbing gently with fine-grade sandpaper.

4 Add some tree shapes at the base of the hills, and develop the hills a little.

5 Add a little texture at the bottom of the picture by gently flicking some colour from an old toothbrush.

6 Add further highlights and make any other necessary modifications by gently rubbing off the paint with a dampened tissue or hog's-hair (bristle) brush.

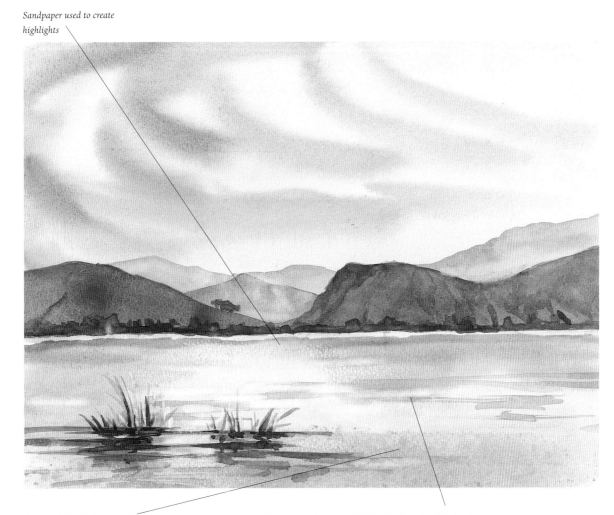

Sandpaper used to create highlights

Spattered effect in foreground

Small, coarse hog's-hair (bristle) brush used to lift off paint and create highlights

Colour and Tone

When you start to paint, you may feel daunted by the vast amount there is to learn – not only about the many ways of applying paint to paper, but about choosing and mixing colours before you even begin. However, once you have understood a few basics you will come to realize that it is largely how you use them to express your own unique vision that really counts.

THE PRIMARY COLOURS

One of the first important facts to learn about colour is that, in any painting, at least one red, one yellow and one blue must be included. These are the three primaries – in other words, they stand alone (unlike green, for instance, which is mixed from blue and yellow, and is known as a secondary colour). All colours are made up of mixtures of these primaries. The three can in fact be extended to six, as it is recognized that there are three 'cool' primaries and three 'warm' primaries.

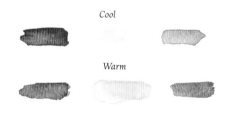

Cool

Warm

The mood and pitch of a painting can be modified by adjusting any of the primaries. For example, bright primary reds such as permanent rose or cadmium red could be substituted by a softer red such as Indian red, burnt sienna, light red or alizarin crimson.

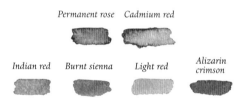

Permanent rose *Cadmium red*

Indian red *Burnt sienna* *Light red* *Alizarin crimson*

Similarly, bright primary yellows such as lemon yellow or cadmium yellow could be substituted by soft, warm yellows such as raw sienna or yellow ochre.

CREATING SPACE AND DISTANCE WITH COLOUR

In a landscape scene, notice how the colours become cooler and softer as they recede. If these characteristics are applied to a painting, a realistic sense of distance and space can be achieved.

In this painting of a sky, an illusion of space has been created by changing the colour as it recedes. Note how the sky overhead (at the top of the paper) is warmer and stronger, changing to a softer, cooler blue at the horizon.

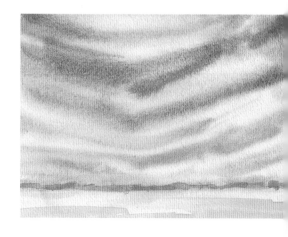

Lemon yellow *Cadmium yellow*

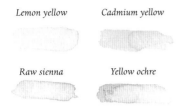

Raw sienna *Yellow ochre*

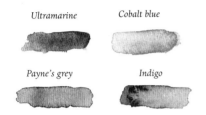

Instead of ultramarine or cobalt blue (bright, summer's-day hues) it would be possible to use Payne's grey or indigo (dark, inky, stormy blues) as more subtle alternatives.

Ultramarine *Cobalt blue*

Payne's grey *Indigo*

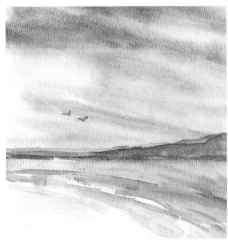

By substituting the true, bright primaries for softer, quieter versions, a painting will itself become softer and quieter.

The softer versions of the three primary colours are often more appropriate for northern landscapes, while the bright primaries may be used predominantly for hot, southern scenes. Using the colours in this way can transform the 'feel' of a painting, as demonstrated in the two versions of the same scene shown below. The colours in the southern landscape are bright primaries: ultramarine, cobalt blue, cerulean blue, Winsor purple and raw sienna. The northern landscape uses softer colours: Payne's grey, ultramarine, light red and raw sienna.

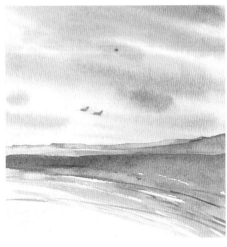

Southern seascape *Northern seascape*

The hills in this painting have been painted in layers, from the distance to the foreground. Each subsequent layer has been made warmer and stronger to give a sense of depth.

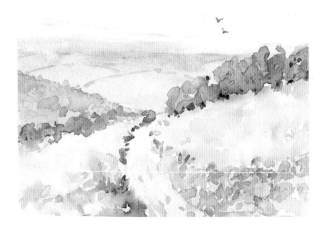

Demonstration

Exploiting colour to achieve a sense of space

In this painting you can see how the strong, warm colours used in the foreground become softer and cooler in the middle distance and cooler still on the horizon.

COLOURS
- **Reds** – light red, burnt sienna
- **Yellows** – raw sienna, cadmium yellow
- **Blue** – ultramarine

PAPER
- Saunders-Waterford Not, 300 gsm (140 lb)

BRUSHES
- English sizes 12 and 8
- Rigger size 2

Method

1 A minimum of pencil drawing was carried out initially, to place the horizon, the two trees and the field in the foreground. The paper was then dampened with a sponge, and the sky painted using soft washes of ultramarine.

2 After leaving this to dry, the distant hills were lightly painted with ultramarine and light red, producing a cool lilac mixture.

3 A wash of raw sienna was laid on the foreground, from the hills down to the bottom of the paper, and left to dry.

4 The colours of the fields were modified, with the warmest and strongest colours (mixes of light red and raw sienna, with touches of burnt sienna) reserved for the foreground field.

5 When painting the tree, it was important to note how its side was in strong shadow. Representing this helped to convey a sense of form. The lightest colour in the tree (mixed from raw sienna, cadmium yellow and ultramarine) was washed on first. The paper was then allowed to dry before the middle and darker tones (made from mixes of the same colours, with touches of burnt sienna) were added.

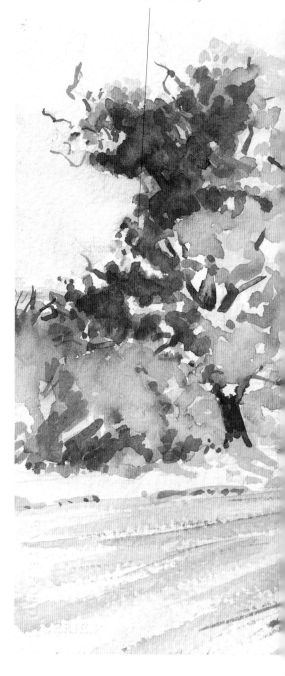

Shadowed side of tree

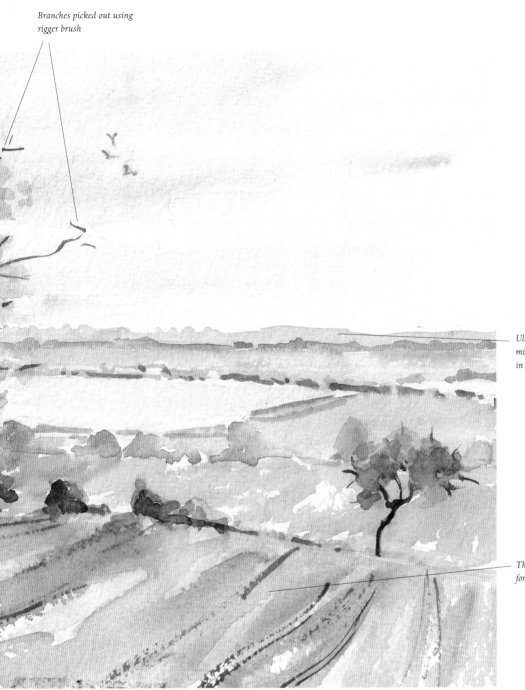

Branches picked out using rigger brush

Ultramarine and light red mixed to create soft colour in distance

Thicker, drier paint used for furrows

6 The branches were painted with the rigger brush and slotted in around the foliage. The other trees and bushes were then added.

7 The furrows in the foreground field were painted using a thicker, drier mixture of the colours used in step 4. The suggestion of birds in the sky added a final touch of interest.

LIGHTS AND DARKS

The effect that light produces when it falls on objects – creating lights and darks – is called tone. This is a very important part of any sketch or painting, from landscapes to still-life compositions. Its effect can be seen clearly in the monochromatic sketches on these pages, but look too at how tone is used in other paintings throughout this book.

The very darkest tones can be found in shadows, and the lightest in highlights, but such strong tones are few and far between – most are in the middle range.

Strong tones in a landscape painting can produce a sense of three dimensions and space. In addition, the use of strong contrast – light against dark, or dark against light – creates drama, as can be seen in these sketches of standing stones.

The importance of different tones – lights, darks and greys – can be seen in the sketches below. A variety of tones creates interest and drama.

You must think about the sizes and shapes of the tones, so that they are balanced and work well with each other. To get this right, it is often a good idea to carry out a few quick drawings – this will help you to think carefully before you start. It can be fun to do these with water-soluble graphite pencils, perhaps adding touches of opaque white paint to highlight the lightest areas.

Analyse the positions of the lightest parts of the scene, and those of the darkest. Think, too, about balance – the tones should not be all on one side of the picture, nor too symmetrical.

Notice here how the stones are seen as a dark tone against the sky in the sketch above, but as a light tone against the sky in the sketch below.

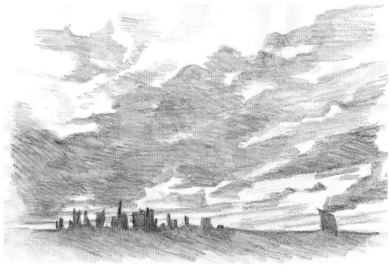

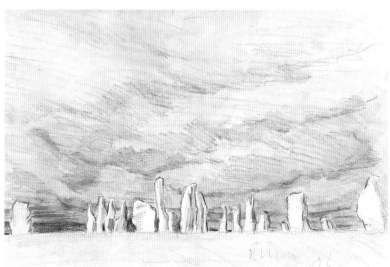

Composition

Think about this at the start. Introducing a strong vertical and/or a strong horizontal roughly one-third of the way across your paper can work well.

Take care with diagonal lines, which can lead the viewer's eye out of the picture. Counteracted with an opposing diagonal, however, they can be dramatic.

In this sketch, the large vertical tree – positioned roughly one-third of the way across the paper – is predominantly dark against the sky. It is balanced by the smaller, dark tree on the right and by the strong horizontal lines of the landscape. The light source – which is coming from the right – has been noted, and emphasized with a little opaque white.

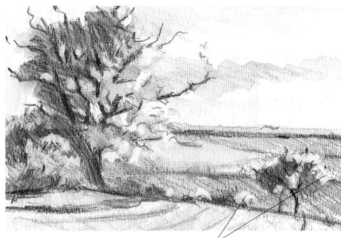

Touches of opaque white paint used to pick out highlights

Here the dark mass of trees on the far side of the lake is complemented by the darks in the foreground water. The light areas within the painting also balance each other well.

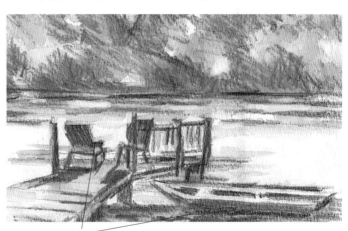

Opaque white paint

The fairly dark background in this still life is used to emphasize the white and light-coloured flowers. Again, the balance of the darks has been carefully considered. Compositionally the vase acts as a strong vertical, with the objects on the table echoing the horizontal plane.

These sketches can be seen translated into paintings on pages 22–3, 60–61 and 90–91.

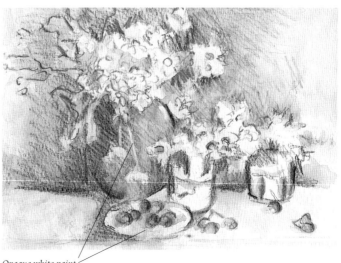

Opaque white paint

Demonstration

Tone in the landscape

In this painting, a dramatic effect was achieved by positioning the dark stones against the lighter sky. The colours were muted to echo the bleak overcast landscape.

COLOURS
- **Red** – burnt sienna
- **Yellow** – raw sienna
- **Blues** – ultramarine, Payne's grey

Note: It is possible to mix Payne's grey from black and either Prussian or Winsor blue. However, working with the colour ready-mixed by the manufacturer makes for ease of use and also prevents too much black from appearing in a painting, which can have a deadening effect (see also page 28). Indigo is similar in colour to Payne's grey, and could be used as an alternative.

Several mixed greys were included in this picture. By limiting the palette, and mixing these greys from just a few colours, the colour has been controlled to create soft, muted shades and tones.

PAPER
- Saunders-Waterford Not, 300 gsm (140 lb)

BRUSHES
- English sizes 12, 8 and 4 (nylon/hair mix)

Method

1 The boulders, water and distant hills were very quickly pencilled in. The paper was dampened with a sponge and the sky was painted, using ultramarine and Payne's grey. Care was taken to leave some of the paper white, to create an effect of light coming through the clouds. This was left to dry.

2 The distant hills were painted using a mix of ultramarine and burnt sienna.

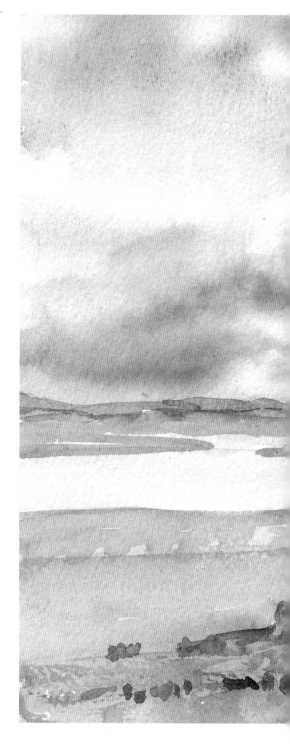

3 The land in the distance and foreground was painted, followed by the boulders, whose strong tones were created from mixes of burnt sienna and Payne's grey.

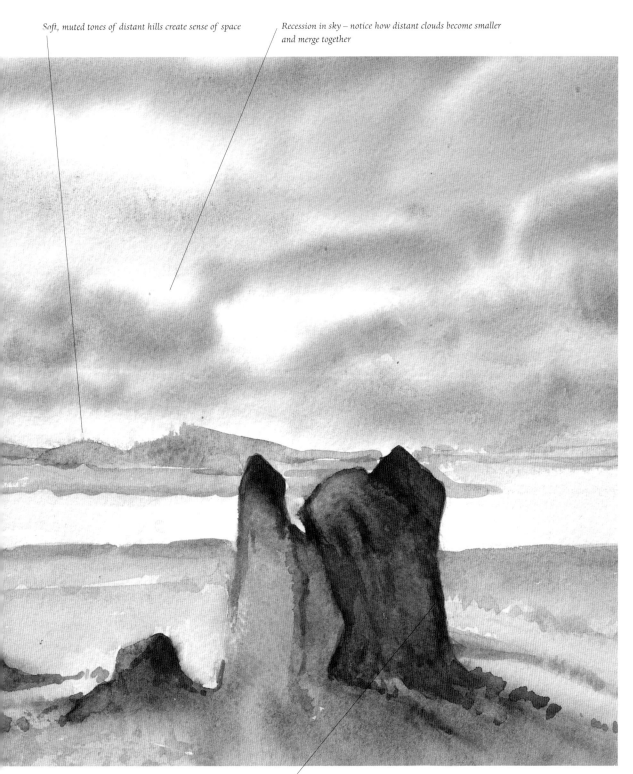

Soft, muted tones of distant hills create sense of space

Recession in sky – notice how distant clouds become smaller and merge together

Strong, dark tones of boulders stand out sharply against lighter background

4 The water and patches in the sky are the lightest areas. The final touch was to tint the water with a very dilute mixture to echo the lightest cloud colour.

MIXING GREYS AND DARKS

To create dark tones or greys I would not recommend using a ready-mixed black, as this often has a deadening effect. Instead, try producing your darks and greys by mixing colours. Doing so makes for 'coloured' darks, which will add interest and vitality to your watercolour paintings.

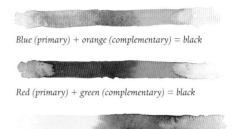

Blue (primary) + orange (complementary) = black

Red (primary) + green (complementary) = black

Yellow (primary) + purple (complementary) = black

Complementary colours

Darks are frequently created by mixing together complementary colours. Complementaries are really the three primary colours (see page 20) in disguise. In theory, when you mix the three primary colours together you will make black, although black can in fact be anything from a dark grey to a dark brown.

In watercolour, if you mix three or more colours together, the result may be muddy and dull. To avoid this, try creating darks by mixing only complementary colours together. In this way, you will only be combining two colours to make your darks, and will avoid the muddy effect.

Complementary colours consist of one primary, 'complemented' by a mix of the remaining two primaries. Mixing a primary colour with its complementary will produce a colourful grey-black.

As already explained with the primaries (see page 20), some colours appear 'warm-ish' in hue while others appear 'cool-ish'.

Mixing together warm complementaries will give you warm darks; mixing cool complementaries will produce cool darks.

Using complementary colours side by side has an interesting effect – they tend to reverberate and to 'complement' one other, as can be seen in the two sketches below.

Yellows and purples

Reds and greens

Making a warm, grainy grey

Ultramarine and burnt sienna are very grainy colours, so mixing them will give you a beautifully textured warm grey. These two colours tend to separate on paper, leading to interesting effects such as those in the sky shown right.

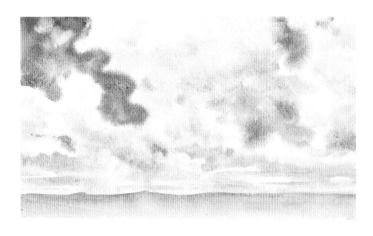

Ultramarine (warm blue) + burnt sienna (warm orange/ brown) = warm grey/black

Making a transparent, cool grey

Permanent rose and viridian are cool colours and are also very transparent, which is of course a vital quality of watercolour. In this small flower sketch, touches of cobalt blue and lemon yellow have been added. Three other interesting cool grey combinations are also shown below.

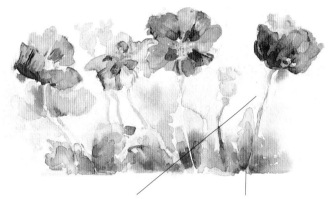

Light grey background wash (mix of permanent rose and viridian)

Stronger grey mix used for darks in foliage

Permanent rose (cool, sharp pink) + viridian (cool, sharp green) = cool grey/black

Indian red + cobalt blue = grainy grey with hint of lilac

Alizarin crimson + Hooker's green dark = rich, deep, transparent dark

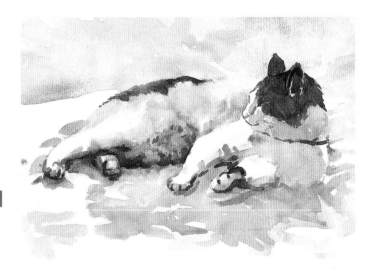

Lemon yellow + Winsor purple = a subtle purple-grey

In this painting of a cat, each grey used a mix of ultramarine, cadmium orange and sepia, with a small amount of raw sienna (a soft yellow). Raw sienna mixed with cadmium orange gave the warmer tones, and mixed with the blue gave a green for the eyes. The whitest parts of the cat used the white of the paper.

TIP

Use pencil for the whiskers, or opaque white gouache.

Demonstration

Angle of chair arm leads viewer's eye into painting

Combining colour and tone

Here both tone and colour have been used to create a sense of sunshine. Although the shadows are fairly dark, they are also full of colour. The contrast between the very light tones and colours, and the darker ones, produces a strong sense of light and shade. On overcast days the tones would be closer together and the colours more muted.

COLOURS
- **Reds** – Winsor red and light red
- **Yellow** – aureolin yellow
- **Blues** – ultramarine, Prussian blue and cobalt blue

PAPER
- Bockingford Not, 300 gsm (140 lb)

BRUSHES
- French size 4
- English size 4

Method

1 The main features of the scene – the three chairs and the table – were lightly pencilled in. The red chairs and the poppies were painted first (with Winsor red and a touch of aureolin yellow), followed by the table (using ultramarine and light red). The blue-ish chair on the left (a mix of cobalt and Prussian blue), and the objects on the table, were then added. It was important to establish these objects well before continuing. The table-top and parts of the chair seats and backs were left white.

2 Next, the light yellows of the grass and foliage (mainly aureolin yellow) were washed on around these objects.

3 The colour and tone of the wall were painted in, and used to define the shape

of the overhanging foliage. The lighter parts of this were put in, followed by the darker tones, using mixtures of all the palette colours.

4 Finally, the shadows around the chairs and table were strengthened with aureolin yellow and mixes of the three blues, which helped to 'throw out' and emphasize their shapes.

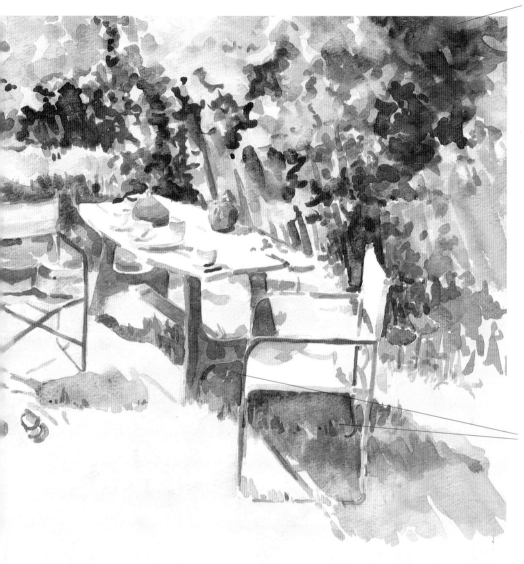

Darks in foliage emphasize light-coloured foliage

Tones of shadows contrast with chair and table, strengthening their shapes

You should be aware that painting outside is very different from painting in the studio. In the latter, the conditions are stable and you will have plenty of time, while outdoors the weather and light may change while you are painting. Therefore you need to approach your painting in a different way.

When painting outside, it is always better to start with the focal point (in the case of this painting, the chairs). If you cannot complete the painting on the spot, you will then have something worthwhile to work on and finish off in the studio.

On a damp day, if you start with wet washes – as you might choose to do with the grass in a picture like this one, or in another picture with a wash for the sky – you could be kept waiting for the paper to dry and so lose valuable time. Instead, if the weather looks changeable or you have limited time, leave the grass or sky for the moment, and add it later in the studio.

Skies

Watercolour is perfectly suited to capturing the sky, with soft diffusions of paint perfectly echoing the changing colours. Skies are most often painted wet-in-wet, with one colour dropped into a coloured wash; they can also be glazed (see page 12). When glazing is used, the initial coloured wash is allowed to dry; the surface is then gently rewetted, and additional colours are floated over the original wash.

Tipping the board
When painting skies, fix your paper to a board – the reason for this is shown below.

Ultramarine
Cobalt blue
Cerulean blue

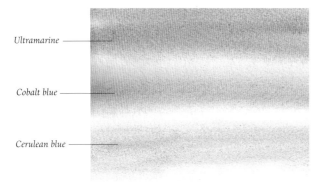

If the work is kept flat, the colour stays where it is.

<div style="border:1px solid #000; padding:4px">
TIP

Whether you choose wet-in-wet or glazing, remember that skies are always most successful when they are completed quickly and then left alone. If you try to do too much 'fiddling' and reworking, you will get yourself into difficulties.

If the board and paper are lifted and tipped, the colours will drift and diffuse to create natural effects.

SKY TYPES

Before you start to paint skies, it is useful to learn a little about the forms they may take.
- Cirrus clouds – these are found highest in the stratosphere, and are the wispy, streaky clouds that we associate with summer.
- Cumulus clouds – these are the puffy white clouds that sit lower in the sky.

- Cumulo-nimbus clouds – found lowest of all in the sky, these are the heavy dark clouds that we associate with rain.

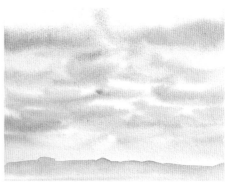

Clouds appear smaller as they recede.

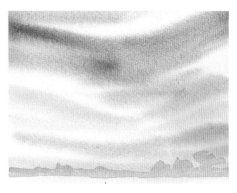

Cloud colours become cooler and softer in recession – in this case, the nearer they get to the horizon.

COLOUR IN SKIES

You can use many different colour combinations for painting skies, and it is important to experiment. Look carefully at real skies in a range of weather conditions and notice how much they resemble watercolour paintings! The following six illustrations show a range of colourful skies you could try. The first

four are painted wet-in-wet; the last two using the technique of glazing.

Yellow ochre

Raw sienna – a gentle, warm yellow – is very similar to yellow ochre, which is usually found in students'-quality paint boxes. Yellow ochre can be used as an alternative to raw sienna. However, the former is more opaque and easily 'muddies', so use it well-diluted.

Staining and non-staining colours

Ultramarine, cobalt blue and cerulean blue do not stain and can easily be sponged off (see page 13). This is not true of staining colours like Payne's grey and Winsor blue.

When you first start to paint skies, start with non-staining blues. Then if you are not happy with the results you can remove all or part of the colour. Once you are more confident, you can make positive use of the staining colours.

Simple sky (cirrus)

These very high formations appear as thin strings of cloud strewn across the blue sky.

1 To create this effect, first wash a very pale solution of raw sienna over the paper.

2 While the wash is still damp, paint strings of ultramarine with a large brush diagonally across the paper. Make the colour lighter towards the horizon, to give the effect of recession.

Cumulus clouds

For a sky like this, work with the paper flat.

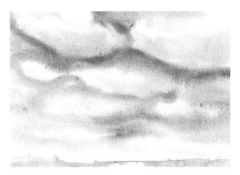

1 Lightly dampen the paper with a sponge and then use ultramarine on a large, pointed brush to create the clouds.

2 Next, introduce the grey tones in the shadowed side of the clouds (mix this colour – a combination of ultramarine and burnt sienna – first on the palette). As the paper is damp, the colour will softly diffuse.

Cumulo-nimbus clouds

The colours used here produce a more dramatic effect. In contrast to the example above, the board is tipped up after painting.

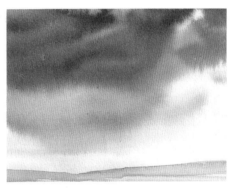

1 Wash on raw sienna and then introduce strong washes of indigo wet-in-wet.

2 While the paper is still wet, add slightly thicker touches of indigo at the top of the paper – this is where the sky is overhead and nearest to you, so it needs to be stronger in colour.

3 Hold the board vertically so the blue-grey runs down, giving a suggestion of rain.

TIP

To test the staining power of different pigments, paint small swatches of each of your colours on two small sheets of paper. Take one sheet and wash it under a tap while the colours are still wet; wash the second sheet once they have dried. You will soon see which are the staining colours!

TIP

To create a warmer sky, start by putting a wash of raw sienna on the paper. While it is still wet, draw out the shapes of the clouds in blue, and finally add the shadows.

Experiment with different mixes for the grey tones in the sky. Change burnt sienna for light red or Indian red, mixing either of these with the ultramarine on the palette to make interesting greys.

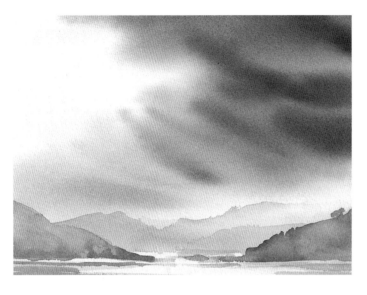

Storm cloud

This sky uses alizarin crimson and Payne's grey instead of indigo.

1 Wash raw sienna over the paper and allow this to dry. Redampen the paper, and then overlay strong washes of alizarin crimson and Payne's grey. The tones should be strongest overhead, curving away to the left and becoming paler as they recede.

Note: To produce the recession in the hills, paint in grey layers from background to foreground. This will give a sense of distance, middle distance and foreground.

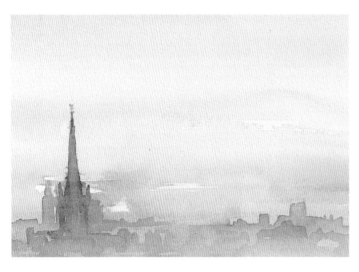

Sunset

The technique of glazing is used to create this very warm sky.

1 First wash raw sienna over the paper, adding more paint towards the horizon where the sun is setting. Allow this to dry.

2 Wash a glaze of cadmium yellow plus cadmium red over the dried wash, strengthening the colour round the sun. Skip some parts of the paper as you work, to mimic the effect produced by the sun as it sets. Leave to dry.

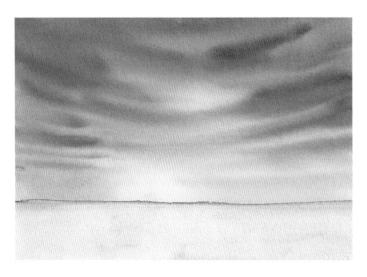

Sunrise

Glazing is also used here.

1 Follow the method used for the sunset above, but add an extra glaze once the first two glazes are dry. Make this third glaze from alizarin crimson, plus a mixture of alizarin crimson with Payne's grey.

TIP

To paint the foreground, use mixtures of very dilute alizarin crimson and Payne's grey. Make the steeple a little stronger in colour so that it appears nearer.

PROBLEMS WITH SKIES

Some common problems are shown below, with suggestions on how to deal with them.

Backruns

These are caused when a wet wash is dropped into a drier wash, and can be used to great effect in the right places. However, when backruns are not required, make the second wash drier and use slightly thicker paint than for the first.

TIP

Try experimenting with Payne's gray, which produces backruns very readily.

Hard edges

Caused when a wet wash hits a dry area of paper, making an edge, these can provide an alternative way of painting clouds. If hard edges are not desirable, check for any areas missed by the wash by tipping up your board and looking at the wet shine on the paper – any 'missed' parts will appear matt.

TIP

If you do make a hard edge by mistake, soften it using a damp sponge or soft tissue.

Too many colours

If your colours are getting out of control, try glazing as shown below.

Stage one: Wash on the light colours, then leave the paper to dry thoroughly.

Stage two: Gently rewet the paper before floating on the stronger, darker colours.

A dirty, 'muddy' appearance

If your sky looks 'muddy', you may have been working on it for too long. What tends to happen if you continue to work as the paint dries is that you will 'take out' paint with your brush, creating dirty marks, rather than adding more colour. Paint your skies quickly and then leave well alone!

TIP

If all else fails and you do not like what you have done, submerge your paper in water (a bathtub is probably the best place for this) and then gently remove the colour using a soft sponge or brush. You will be able to remove just a little of the colour, or much more, but it will not disappear totally. Instead, you will be left with a very soft, pale version of your previous sky. This may work in its own right, or could be the starting point for a new painting.

Demonstration

Tackling a complex sky

This complex sky was achieved with a combination of wet-in-wet work and glazing.

COLOURS
- **Red** – rose madder
- **Yellow** – raw sienna
- **Blue** – Winsor blue
- **Green** – viridian

PAPER
- Saunders Rough, 300 gsm (140 lb)

BRUSHES
- English sizes 8 and 2, French size 4

Method

1 The hills were lightly drawn in pencil. The paper was then dampened with a sponge and Winsor blue and viridian, used individually and mixed together, were applied in the sky area and right down through the hills.

2 While the paint was still damp, the darker purple clouds – a slightly thicker mix of Winsor blue and rose madder – were painted into the blues and greens.

3 As the paper had a good texture, the surface of the foreground water was achieved simply by rolling a dry brush over the earlier wash. The colour was then just picked up from the raised parts of the paper, but remained in the 'wells'.

4 The hills were painted with thin glazes of colour, from distance to foreground. When dry, further more intense colour was used wet-in-wet in the foreground.

5 Next the yellow in the sky was painted as a gentle glaze in some parts of the painting. As only selective areas of the sky

TIP

Winsor blue – used here as one of the sky colours – is beautifully transparent and ideal for this type of effect. However, it is a staining pigment (see page 33), so take care when you use it as any errors will be indelible!

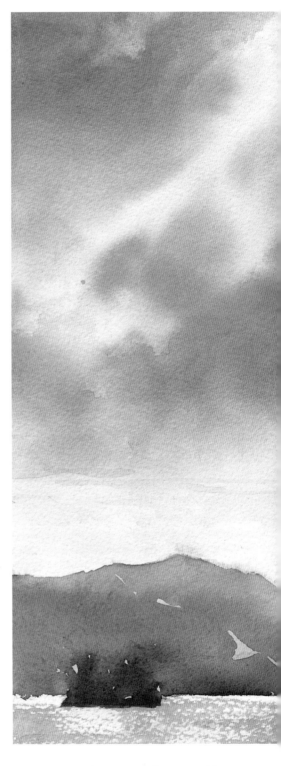

were rewetted, care was taken to avoid hard edges forming by gentle blotting at these points (see also page 35).

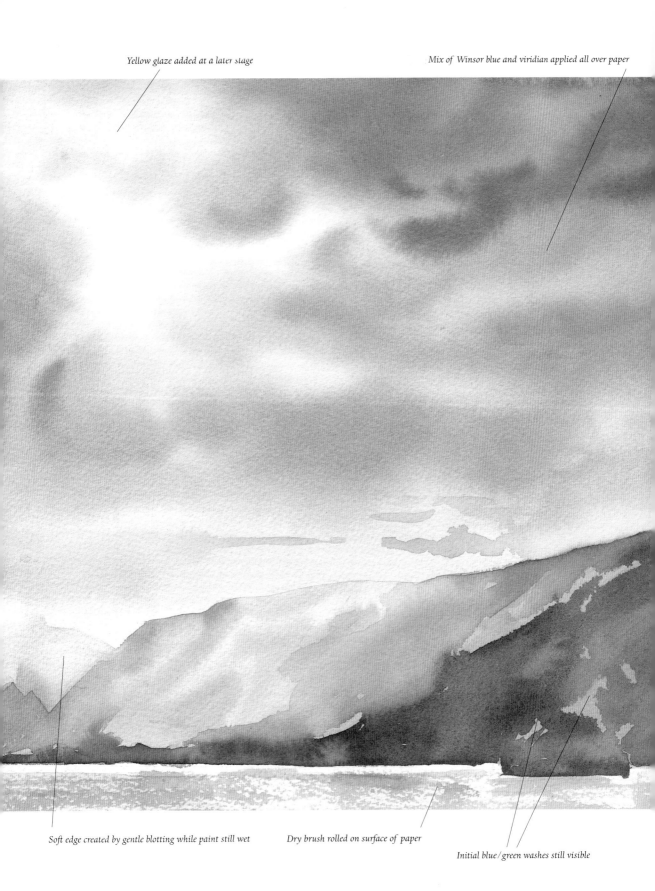

Yellow glaze added at a later stage

Mix of Winsor blue and viridian applied all over paper

Soft edge created by gentle blotting while paint still wet

Dry brush rolled on surface of paper

Initial blue / green washes still visible

Trees and Shrubs

It is important to see trees and shrubs within the landscape as shapes, tones, and colours affected by light, against a background. Once you have observed and understood this basic rule, you will find them much easier to paint.

TREES WITH FOLIAGE

<div style="float:left;">

TIP

When you are more experienced you may be able to paint from light to dark in one go, without drying the paper in between. However, the colours can be difficult to control, so as a beginner you may find it best to do this in two or three stages, allowing the paper to dry between each stage.

</div>

The following are some general guidelines when painting trees in full leaf.
- Observe the general shape of the tree, and look at its tonal relationship with the background.
- Locate the light source. Which parts of the tree are lightest and which darkest?
- Start with the foliage, and then slot in the trunk and branches – otherwise they may show through and dominate the study.

- Leave some spaces within the foliage for the sky to peep through.
- It is generally easier to work from light to dark (except in certain circumstances – see page 43), so establish the lightest colours and tones first.
- Try working the two lightest tones wet-in-wet (see page 12), remembering to leave gaps. When the paper has dried, introduce the darkest tones.

EXERCISE – PAINTING SIMPLE TREE SHAPES

Practise looking at trees merely in terms of their shapes, tones and colours by painting the summer and autumn trees below. These were painted freely with no prior drawing in pencil, using a French size 4 brush with a good point.

TIP

If the dark tones look too dark, soften them by adding further touches of water while the paint is still wet, or experiment with gently blotting some of the paint with a soft tissue.

 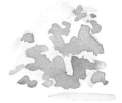 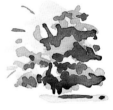

1. *Lightest colours and tones of the tree and its shadow washed on using mixes of cadmium yellow and Prussian blue, leaving touches of sky showing through.*

2. *Middle tones added while the paper is still slightly damp, using the same colours but with a touch of burnt sienna. Leave to dry.*

3. *Add a little more burnt sienna to darken the colour further, and put in the deepest tones. Slot the trunk and branches into the gaps.*

1. *Wash on the lightest colours, using a mixture of cadmium orange, new gamboge and light red.*

2. *Add the middle tones while the paper is still slightly damp, using the same colours with a little burnt sienna. Leave to dry.*

3. *Put in the tree trunk and branches, adding a little sepia to the mixture to darken it further.*

TREES WITHOUT FOLIAGE

As when painting a tree with foliage, the first step is to examine the general shape of the tree and its tonal relationship with the background. At the time of year when trees shed their leaves they can appear very dark against the sky, as in the picture below where the tree trunks and branches dominate and stand out against the light sky (see also pages 44–5).

Below, the distant trees are soft and muted in colour, and there is an absence of detail; the two foreground trees are darker and stronger in colour.

The branches catching the light were masked out and then a background wash was floated over the top. When this was dry

the masking fluid was rubbed off to reveal the white paper beneath.

Cool colours – Prussian blue, burnt sienna and raw sienna – were used for this picture.

TIPS

- A rigger brush, or a flat brush used edge-on (see also page 15), can be useful for painting fine branches.
- Try rolling a fairly dry, round brush on its side to paint the small twigs at the ends of branches.
- Avoid wetting the paper too much, or you may lose control of the colours.

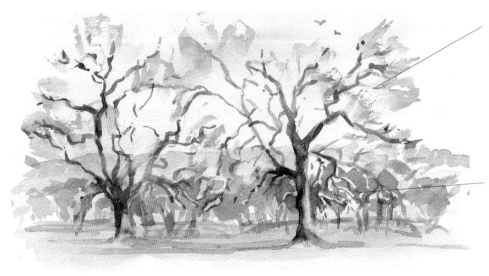

Small twigs painted using round, dry-ish brush on its side

Masking fluid applied where branches catch light

In the sketch of bushes below, the light source – coming from the left – has been noted. The lightest tones and colours were established first, in broad sweeps. As these dried, the darker tones and shadows were introduced.

TIP

Do not start by painting individual leaves! Instead, think of the overall mass. Concentrate on painting the lightest parts of the foliage and then use the darks to set these off, rather than focusing on the individual shapes and colours of the leaves (see also overleaf).

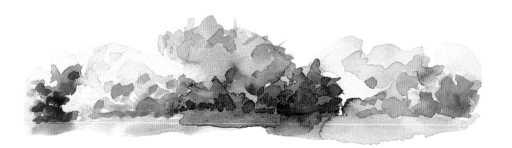

PAINTING FOLIAGE

When painting trees or shrubs, firstly note the overall colour and shape of any tree or shrub, one against the other, or against the background. Avoid becoming sidetracked into focusing on any particular tree, or on its individual leaves. You are looking for relationships – one shape of tree or colour of foliage against another. If you keep to these basic rules, these subjects will become much easier to paint.

You should also be thinking about other comparisons. For instance, is this particular tree taller than the one behind it? Is the foliage of that shrub yellow-green in relation to the blue-green of the one next to it? If you do this, you will start to see the overall shapes and colours of the trees and foliage much more clearly. Then locate the light source.

Once again, when you start to paint, work from light to dark. You will then find that the details of individual leaves become unimportant and you can concentrate instead on letting the medium work for you.

EXERCISE – CAPTURING THE COLOUR OF FOLIAGE

This simple exercise will help you to practise some of the basic principles of painting foliage. (*Note*: Using ready-mixed Hooker's green dark will enable you to work quickly; when combined with rose madder it makes a rich, transparent dark.)

COLOURS
- **Reds** – rose madder, light red, alizarin crimson and sepia
- **Yellows** – cadmium yellow, yellow ochre and lemon yellow
- **Blues** – Prussian blue and cerulean blue
- **Green** – Hooker's green dark

PAPER
- Saunders-Waterford Not, 300 gsm (140 lb)

BRUSH
- French size 4

Stage one
(Above right) Lightly pencil in the outlines of the trees, shrubs and path. Wash the lightest colours and tones, and some of the middle tones, on to the shrubs, the path and the foreground grass, working wet-in-wet (see page 12). For the lightest tones, use the following: mixes of the three yellows for the yellow foliage, adding a touch of Prussian blue for the greener areas; very dilute light red with a touch of alizarin crimson for the path, and a slightly stronger tone for the purple foliage; and a pale wash of cerulean blue for the blue foliage. Wash in the sky, then leave everything to dry.

Stage two
(Below right) Add the darker colours and tones on the foliage (using stronger mixes of the colours used earlier, with touches of sepia to make the darkest tones), and the shadows across the path, and leave to dry. Finally, paint in the darkest tones of all, which are concentrated under the arch. The stronger contrast in this area draws in the viewer's eye, and creates a focal point.

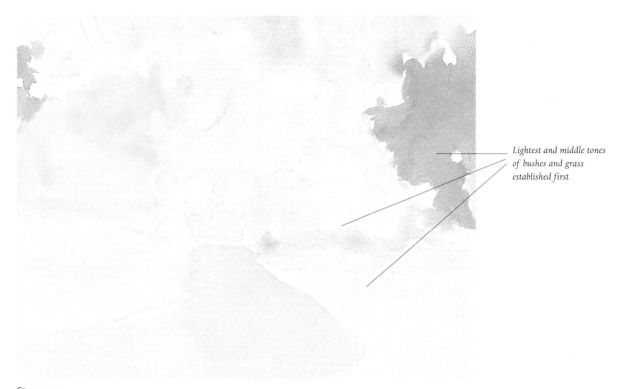

*Lightest and middle tones
of bushes and grass
established first*

Stage one

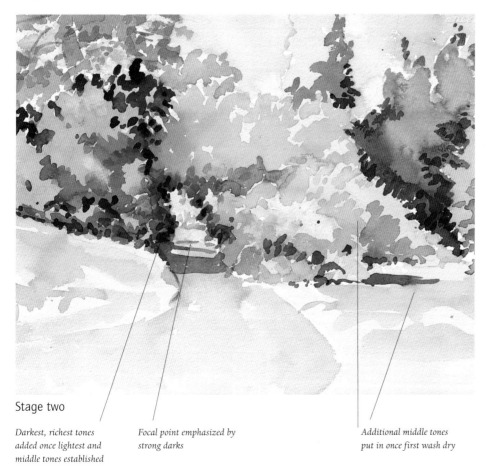

Stage two

*Darkest, richest tones
added once lightest and
middle tones established*

*Focal point emphasized by
strong darks*

*Additional middle tones
put in once first wash dry*

TREES IN THE PARK

Two ready-mixed greens were used in this painting (see Tip). The blues and greens are all cool, transparent colours, and were chosen so that the blue/greens in the trees could be represented accurately.

Two yellows were used: cadmium yellow – bright and sunny – and yellow ochre – warmer and softer. When mixed with the blues and greens, these produced a wide range of warm and cool greens.

COLOURS
- **Reds** – light red and rose madder
- **Yellows** – cadmium yellow and yellow ochre
- **Blues** – Prussian blue and cobalt blue
- **Greens** – viridian and Hooker's green dark

PAPER
- Winsor & Newton Not, 640 gsm (300 lb)

BRUSHES
- French size 4 and English size 4

Stage one
A light pencil sketch positioned the bench and figure, and the foliage outlines.

Stage two
The lightest colours of the bench and the figure were painted first. Once these were established, the painting was worked from light to dark. Washes of the lightest colours (cadmium yellow for the yellow tones, with a little Prussian blue added for the greens) and some of the middle tones (cobalt blue and cadmium yellow for the greens) were painted wet-in-wet over the foliage and the grass, and allowed to dry.

Stage three
The darker tones on the tree trunks (a mix of light red and rose madder for the lighter areas, with a touch of Prussian blue for the shadowed sections) and on the two benches were added. Further detail was added to the figure and bench.

Cool, transparent colours used for tree foliage

Lightest colours of figure and bench put in first, then detail added later

Careful observation made of pattern of light and shade

TREES IN CHANGING LIGHT

Although the general principle of painting in watercolour is to work from light to dark, this is not a steadfast rule. Occasionally, when working in a changing, transient light where nothing stays the same for very long, you may find it better to work from dark to light, establishing the shadows and the darker tones first. You can then paint the lighter tones over the top, exploiting the transparency of watercolour by allowing the darker colours to show through.

This method was used for the picture shown here. These trees were painted in the late afternoon, when the light was changing rapidly and the sun was continually coming out and then disappearing again behind a cloud.

COLOURS
- **Reds** – burnt sienna, light red and sepia
- **Yellow** – cadmium yellow
- **Blues** – cerulean blue and cobalt blue
- **Green** – viridian

PAPER
- Saunders-Waterford Not, 300 gsm (140 lb)

BRUSH
- French size 4

Stage one

Once a light pencil sketch had been drawn, the shadows on the trees and grass were painted rapidly (viridian and cadmium yellow were combined to make the light, bright green of the grass). The light catching on both trees and grass was left as the white of the paper. The paint was then allowed to dry.

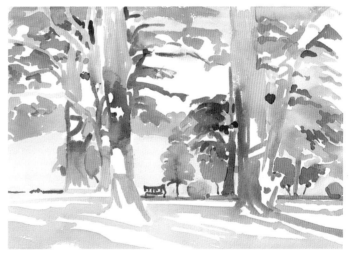

Stage two

The reserved white shapes where the light had fallen, and the previously painted areas, were tinted with an overlaid, transparent, pale wash of cadmium yellow. This gave extra depth of tone while allowing the original colour to show through.

This second stage was carried out on the spot. However, as the main work had already been done, the picture could have been completed in the studio at home.

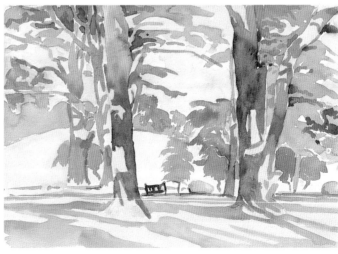

Demonstration

Trees in winter

TIP

A rigger brush, as used here, can be very useful for painting the exposed smaller branches and twigs of trees in winter. It should be handled in the so-called 'oriental' style – using deft, light wrist movements – to flick in the smaller branches and twigs.

When painting winter trees, it is generally easier to start with the trunks, moving on to the middle branches, then to smaller branches and finishing with the twigs. This order of working was used here.

Maximum use was also made of colour theory – the rule that colours become cooler and softer as they recede – to create a sense of space. Cool, purple-blues were used in the distance, and warm ochre tones in the foreground.

COLOURS
- **Reds** – light red and burnt sienna
- **Yellows** – raw sienna and yellow ochre
- **Blues** – monestial blue, ultramarine and cerulean blue

PAPER
- Saunders-Waterford Not, 300 gsm (140 lb)

BRUSHES
- English sizes 12 and 8
- Rigger size 2

Method

1 The minimum of drawing was carried out – just a few pencil marks to establish the horizon and position of the trees. The paper was washed with raw sienna – a soft, warm, transparent yellow – and then allowed to dry. This created a warm, delicate backdrop for the painting.

2 The paper was then gently redampened and the sky glazed using mixes of monestial blue, ultramarine and cerulean blue. These colours are all very grainy (see page 14), giving a nice texture to the sky.

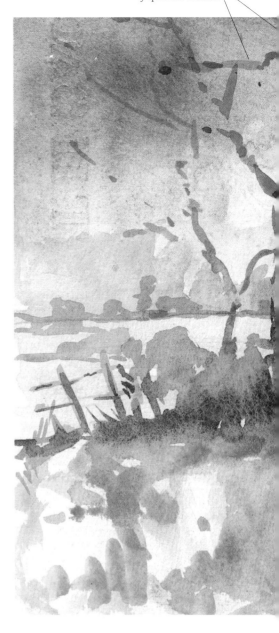

Cloud colours create sense of space and recession

3 The next step was to establish the tonal relationships of the trees against the background, and to consider whether they were darker or lighter than the sky. The trees were then painted in: first those in the distance (a mix of ultramarine and burnt sienna), then in the middle ground, and finally in the foreground. The colour was made

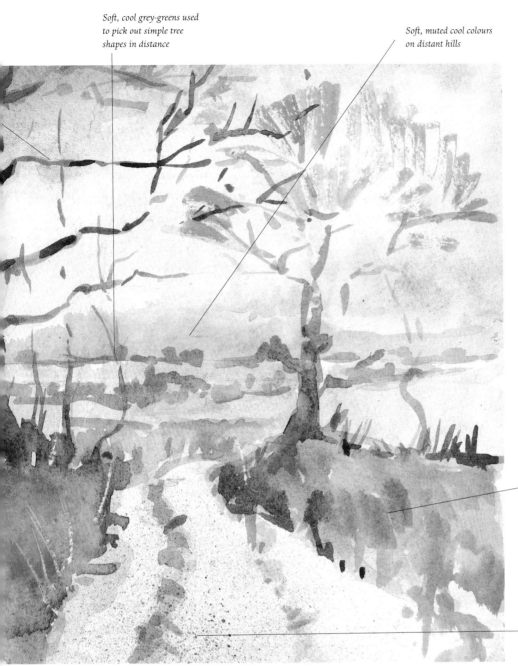

*Soft, cool grey-greens used
to pick out simple tree
shapes in distance*

*Soft, muted cool colours
on distant hills*

*Warm, advancing colours
in foreground*

*Texture created by
spattering with
toothbrush*

increasingly warmer and stronger as it
came closer, by using less blue and
adding yellow (raw sienna).

4 When the trees were dry, the warm
colours of the foreground were painted.
Some texture was added to the path by
lightly spattering on paint from an old
toothbrush (see page 14).

5 Finally, a few light foreground grasses
were scratched out using a sharp knife.

Buildings

It is generally easier to paint buildings looked at 'straight on' (as in the demonstration on pages 52–3) than when they are in perspective and receding away from you. This is because, in the latter case, any horizontal parts appear to remain horizontal, whereas parts of the building going away and receding into the distance appear to slope up or down.

You will need to think about this aspect carefully in any paintings that you make of buildings in perspective. However, understanding some basic rules should help you considerably. If these seem daunting, it is worth remembering that – although they are important – the overall balance of the composition and a good feel for the scene you are capturing can 'carry' a painting, even if the perspective is not quite accurate.

THE 'VANISHING POINT'

Sides of a building that are parallel appear to come together as they recede, and in theory they would eventually meet at a point on the distant horizon. This is usually referred to as the 'vanishing point'.

It is important to establish whether you are looking up at a receding side, or down on to a receding side. If you are looking up, the sides will slope down and meet at the point on the horizon. If you are looking down, the sides will appear to slope upwards and meet at the point on the horizon (see the sketch below).

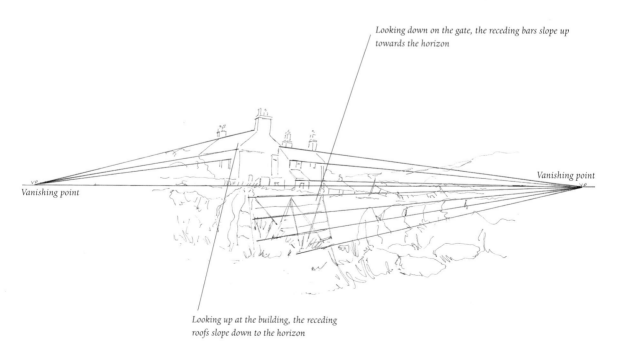

Looking down on the gate, the receding bars slope up towards the horizon

Vanishing point

Vanishing point

Looking up at the building, the receding roofs slope down to the horizon

FARMHOUSE IN ANGLESEY

Many artists use photographs as a source of information for their paintings. However, there are dangers when relying exclusively on photographs, and carrying out the simple exercise below should help to increase your awareness of them.

The main potential problem is that a camera takes photographs indiscriminately, with no 'eye' for composition. To overcome this, it is a good idea to carry out a sketch from any photograph before attempting a painting. By doing so, you will be more aware of likely problems.

EXERCISE – TRANSLATING FROM A PHOTOGRAPH

To carry out the painting on pages 50–51, which was based on the photograph and subsequent sketch below, the vital first step – as in all paintings – is to establish where the light is coming from. You can then decide where to place the shadows – which side of the building should be dark and which light, and so on.

Outlined in the table below are some of the problems that were raised by the photograph shown, along with the solutions implemented in the sketch.

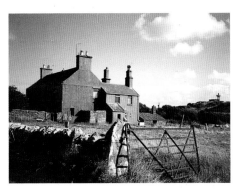

(Above) Photograph of subject on which painting on pages 50–51 is based.

(Right) Preliminary sketch establishing light and shade, and basic composition.

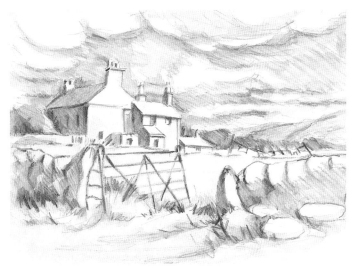

PROBLEM	SOLUTION
• Darks in the photograph are too heavy.	• They should be reconsidered and lightened.
• The wall sits at the bottom of the photograph, so there is no foreground.	• Imaginary foreground created (when adding to a composition like this, the fall of the light must be considered – in this case, it is coming from the right).
• The gate leads the eye out of the picture, rather than into it.	• It has been moved to the left.
• Right side of photograph stops abruptly.	• An imaginary further stretch of wall has been introduced.
• Clouds do not enhance the picture.	• Clouds have been put in right across the sky (you could make an addition such as this from imagination, from a sketchbook drawing, or even from another photograph of a good sky).

Having produced a sketch, now is the time to start on the painting itself, based on the reinterpreted photograph. A very limited palette is needed here.

COLOURS
- **Red** – light red
- **Yellow** – raw sienna
- **Blues** – ultramarine and Prussian blue (Winsor blue could be used instead of Prussian blue – these colours are very similar)

PAPER
- Saunders-Waterford Not, 300 gsm (140 lb)

BRUSHES
- English sizes 12, 8 and 2

Stage one

1 Using an HB pencil, lightly draw in the basic features.

2 Mask out the washing on the line with masking fluid.

3 Dampen the sky area with a sponge.

4 Draw out the shapes of the clouds in ultramarine, making them smaller and more condensed as they recede. Work a mix of ultramarine and light red into the shadowed side of the clouds, then leave to dry.

5 Wash raw sienna over the foreground. As it dries, paint a hint of light red mixed with ultramarine on the roofs to produce their slightly greyer colour. Leave the paper to dry.

Stage one

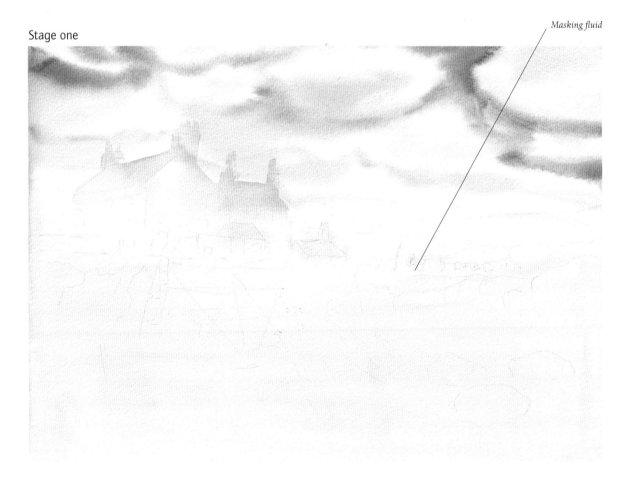

Masking fluid

Stage two

1 You should now aim to get the focal point established, so paint in the shadowed sides of the house, using a mixture of light red and ultramarine.

2 Over the yellow wash, mask out some of the grasses in the foreground. This will keep them light when you introduce darker colours in this area.

Stage three

1 Use a mix of Prussian blue and raw sienna to paint the trees behind the house, keeping in mind the direction from which the light is coming.

2 Paint in the gate (light red and raw sienna) and the green in the field behind it (raw sienna and ultramarine), and add some colour on the wall and in the foreground. Leave the paper to dry.

Stage two

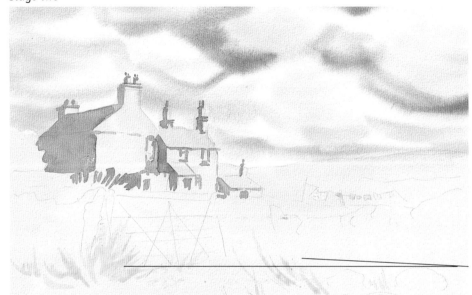

Masking fluid

Stage three

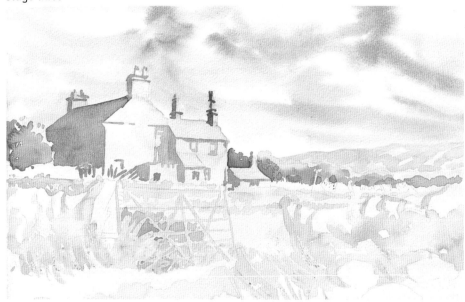

Stage four

1 Using different mixes of all the colours, paint in the shadows on the wall and gate, and in the foreground. Leave the paper white where the light catches the top of the wall and parts of the gate. Observe the interesting shadow of the gate on the gatepost.

2 Carefully spatter some texture in the foreground with an old toothbrush. Any paint blobs which are too large can be absorbed with a soft tissue.

3 Remove the masking fluid by rubbing it gently with a finger. Develop some of the grasses, and introduce some hints of colour on the washing line.

4 Finally, develop the shadows on the house a little further. Note how the windows on the shadow side of the house merge into the shadow, whereas those in the sunlight can be seen more obviously. Here there is more contrast between lights and darks.

5 Note the use of negative painting, where darker tones are painted around the lighter ones in order to make the lighter ones stand out. This can be seen here with the dark foliage behind the light-coloured washing, and the dark tones of the wall behind the foreground boulders and grasses. This technique is also used where the predominately dark colour of the gate is thrown out against the lighter field.

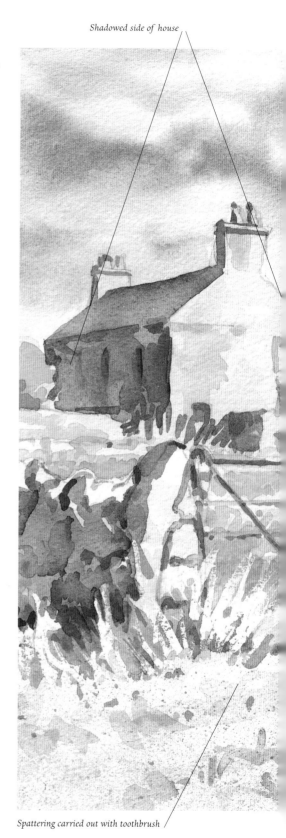

Shadowed side of house

Spattering carried out with toothbrush

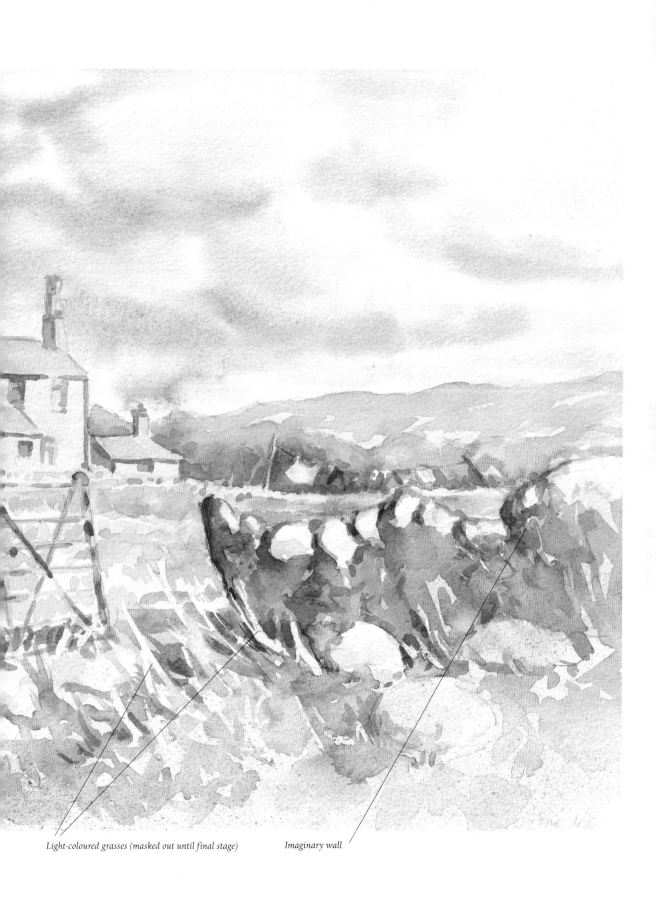

Light-coloured grasses (masked out until final stage) *Imaginary wall*

Demonstration

Painting a house viewed 'straight on'

This picture, of a house in Washington, D.C., was painted on the spot, and therefore had to be tackled in a different way from the farmhouse on the previous pages, which was painted in the studio.

As has already been mentioned on page 31, when painting outside you will face problems that do not apply in the studio. Outdoors, the light or the weather can change suddenly, giving you only a very limited time in which to paint. You may also have problems with the paper drying too quickly, or not at all!

Painting in the comfort of the studio, without these problems, and possibly using photographs for information, is always time well-spent, but it is also important to paint from real life. Without direct experience of painting from the real world 'translating' from a photograph can be difficult.

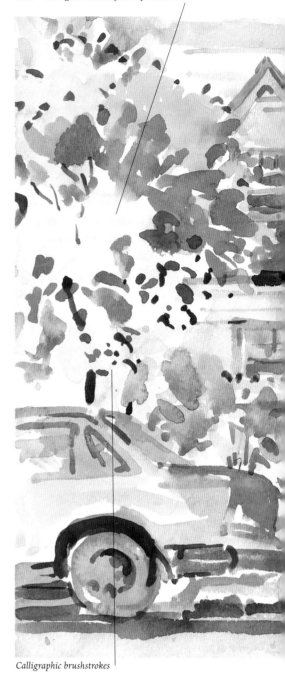

Calligraphic brushstrokes

COLOURS
- **Reds** – cadmium red, light red and burnt umber
- **Yellows** – cadmium yellow and yellow ochre
- **Blues** – Prussian blue and ultramarine
- **Green** – Hooker's green dark

BRUSH
- French size 4

PAPER
- Bockingford Not, 300 gsm (140 lb)

Method
1 A minimum of pencil drawing was carried out, to plot the main features of the house, the foliage and the car.

2 The rest of the 'drawing' of the house was carried out with a paintbrush, and extended to the washes. The focal point – the door – was painted first, with work progressing to each of the windows in turn, then to the edge of the roof, then to the top of the chimney, and so on. As it was a hot day, each colour dried rapidly, enabling them to be used in quick succession. The shadows on the house were painted once the wash underneath

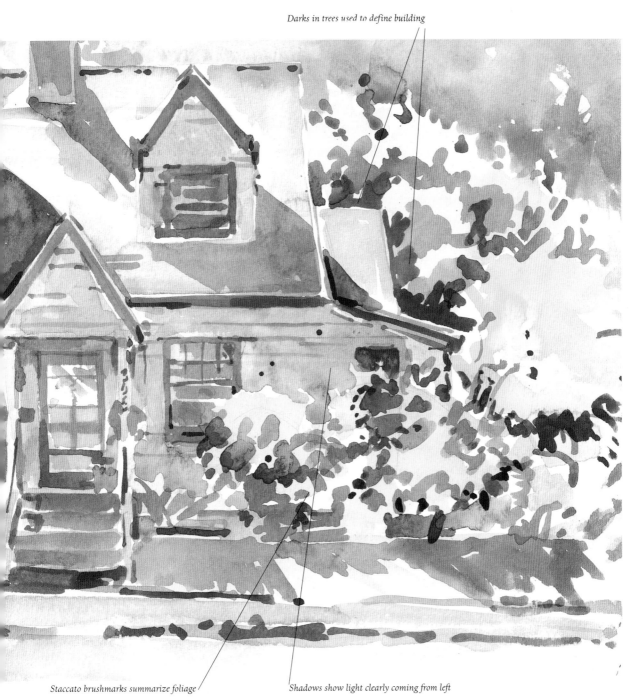

Darks in trees used to define building

Staccato brushmarks summarize foliage

Shadows show light clearly coming from left

was dry, and the car added in the foreground. The parts of the walls hidden by foliage were left unpainted, to avoid dulling the subsequent light washes used for the foliage.

3 The foliage was painted using cadmium yellow for the lightest areas, and cadmium yellow with yellow ochre and Hooker's green dark and applied using 'calligraphic' brushmarks for the darker. The pavement shadow was then added.

4 Finally the sky was washed in, using a mix of ultramarine with a touch of Prussian blue.

Water

It is useful to remember when painting water that it has no colour itself, but reflects everything around it. This means that on a dull day the colours in water will be muted; on a bright day they will be vibrant.

When water is still and calm, the reflections in it may look like mirror images of the objects that they represent. However, when the wind is blowing, the reflections break up and ruffles will start to appear on the surface.

Note how the position of each of the posts shown below affects the angle of its reflection in the water. In each case the water is moving, so that the reflections are broken up into jagged shapes.

Experiment by painting reflections on damp and dry paper. Different effects will be achieved in each case, as is demonstrated in these three studies below.

MIRROR-IMAGE REFLECTION
(Below) Here the paper was dampened, and the reflections painted so that they dispersed and blurred together.

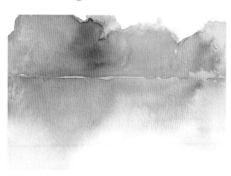

MIRROR-IMAGE REFLECTIONS AND SURFACE MOVEMENT
(Right) Here both techniques have been combined. The reflections were painted on to damp paper and then, when these were dry, the surface movements painted on top.

SURFACE MOVEMENT
(Below) The movement on the water was suggested by painting on dry paper with brisk sideways strokes, using a pointed brush (a similar effect could be achieved with the sharp edge of a large, flat brush).

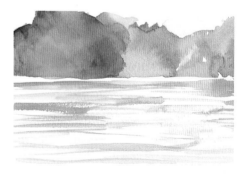

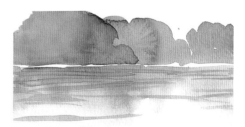

(Right) Here the 'shine' on the water was produced by dragging a fairly dry brush, held sideways, across the paper. With this technique, most effective on Rough papers, only some of the paint catches the surface.

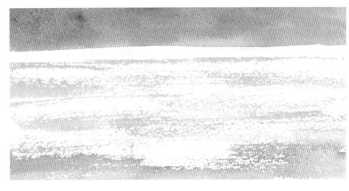

(Centre) The lines of light in this water were achieved by applying the wash and then 'lifting off' some of the colour with a ½-inch flat nylon brush, wetted and used edge-on. However, note that this technique only works with non-staining colours (see page 33) – a mix of ultramarine and burnt sienna was used here.

Once the paint was dry, the effect of broken light was produced by rubbing in several areas with fine-grade sandpaper.

(Below) These reflections were a mix of working wet-in-wet, and on dry paper. As in the sketch above, fine-grade sandpaper was used to bring out some of the 'lights'.

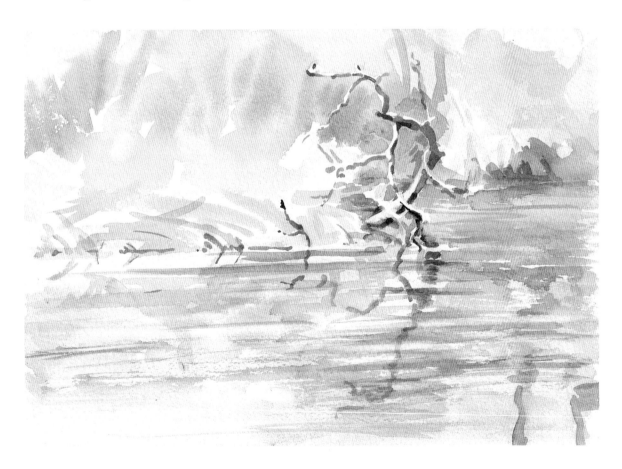

COLOUR IN WATER

When painting an expanse of water – such as the sea – remember that its colour is influenced by the sky and will change accordingly.

The streak of light in the picture below, along the horizon, was produced by holding a piece of card along the horizon's edge.

The paint underneath was then briskly, but carefully, sponged off (a piece of damp tissue could be used instead) to leave the thin, straight line.

The foreground was rubbed in places with fine-grade sandpaper to put a sparkle on the water, and the palm trees added last.

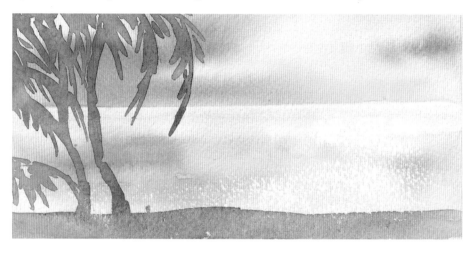

EXERCISE – PAINTING WATER IN A GLASS CONTAINER

This can be a fascinating subject to paint, as the way in which the water and glass pick up and refract the colours around them is always unexpected. Here, the glass was placed on a sheet of bright yellow paper, and painted using an English size 8 brush. Use this example, or select a container of your own, to practise the technique.

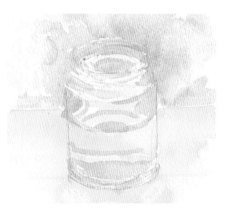

1. *Draw in the glass lightly with pencil. Next, wash in the colours underneath and behind the glass (cadmium yellow was used for the sheet of paper, and a mix of ultramarine and burnt sienna for the grey wash). Reserve the highlights as white paper by painting around them. You could use masking fluid for this if you prefer, but take care not to overdo this or the result may look clumsy.*

2. *Add the darker tones within the glass and the water, and then the shadows on the table. Remove the masking fluid if used, and modify the retained highlights.*

TONE IN WATER

As well as looking carefully at the colours reflected in water, it is also important to think about their tonal relationships. What tone, as well as colour, are the reflections? In other words, are they darker or lighter than what they are reflecting.

If there are any objects on the water (birds or boats, for example) think about whether they appear dark against the water, or light. In the study below left, the bird is light in colour but still appears darker than the water. In the right-hand study, the swan is light against the dark reeds and water.

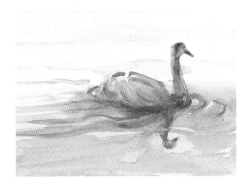

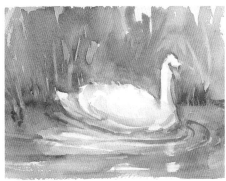

(Below) In this painting, observe the tonal relationship of the swans. One is dark against the water, the other is light. Notice the varying tones, as well as colours within the water, the reeds and the trees.

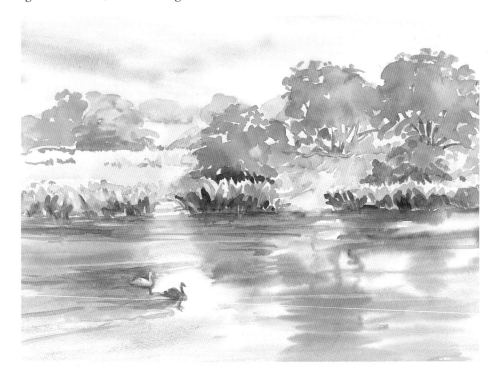

DISTANT WATER, AND DARKENING WITH A GLAZE

In the first painting here, the tones are as important as the colours. The building and the foreground are predominantly dark against the light water behind. The water is very simply painted, echoing the colours in the sky.

In the second interpretation of the same subject, the tones are less strong. This gives the painting a different atmosphere and a sense of a different time of day. As in the first picture, the water is picking up the colours reflected in it – the sky here is lighter, and so the water is correspondingly lighter.

TIP

If tones that you have used in a painting are not sufficiently dark, try glazing with an appropriate colour over the top (see page 12). In this painting a wash of colour was taken over the buildings and the foreground.

As always with glazing, when using a wash in this way keep it transparent by using the correct proportion of water to pigment. This can be a fairly fine balance as, although you need sufficient water for the quantity of pigment, if you use too much water the wash may simply end up looking 'dirty'.

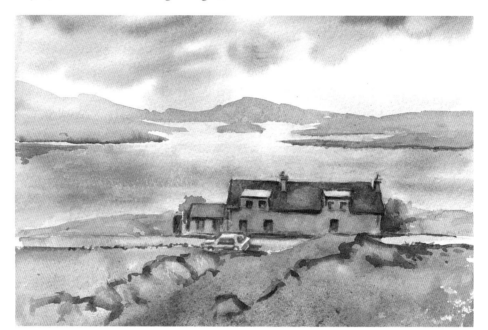

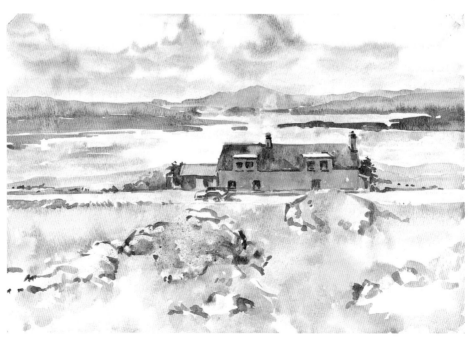

PAINTING WAVES

Many people feel daunted by the prospect of tackling constantly moving waves. However, the movements are endlessly repeated, and by spending a little time watching waves you will soon get to grips with the way they form and break. As when painting trees and foliage, aim for a general idea, rather than trying to focus on details.

In this simple sketch, the water was painted with a mix of ultramarine and light red. The waves are simply the white of the paper, and these were retained by deftly painting around them. An alternative method would be to reserve the white areas using masking fluid.

Reserved white of paper used for foam of waves

Birds and figures are dark against water

The foam of these breaking waves largely comprises the white of the paper. The deeper waves were defined by darkening the shadows beneath them. Some of the sea water was brought across the original sand colour, so that the sand shows through. The figures and the birds appear mainly dark against the water – they are seen as basic shapes rather than in detail.

 The colours used were light red, raw sienna, ultramarine and cerulean blue. Opaque white was also added in places. This looks grey against the white paper, so has only been used to lighten some of the darker colours.

Original sand colour with glaze of sea colour overlaid *Reflections in water*

Demonstration

Moving and still water

In this painting, which was worked from light to dark, the distant water is still, and reflects the dark tones of the trees. Notice the simplified tree shapes – basically very dark in colour, with the odd touch of light.

In contrast, the water in the foreground is moving, shown by the way in which the brushstrokes have been painted. Note, too, how the colours of the posts and the boat are picked up in the colours of the water. The chairs on the landing are seen mainly as dark shapes against the lighter water.

COLOURS
- **Reds** – alizarin crimson, light red, burnt sienna and burnt umber
- **Yellow** – cadmium yellow
- **Blues** – Prussian blue and cerulean blue
- **Greens** – viridian and Hooker's green dark

PAPER
- Saunders-Waterford Not, 300 gsm (140 lb)

BRUSHES
- English sizes 8 and 2

Method

1 A quick pencil sketch was made of the jetty, boat and the water line on the far bank. The painting was begun with the jetty, with its lightest tones painted first.

2 The lightest tree tones were then painted, using a pale wash of cadmium yellow.

3 The jetty, dry by this time, was now developed further. Once this was done the first wash on the trees had dried, and the darker green tones (mixes of viridian and Hooker's green dark, with a touch of alizarin crimson) were laid over the yellow. These tones were gradually taken

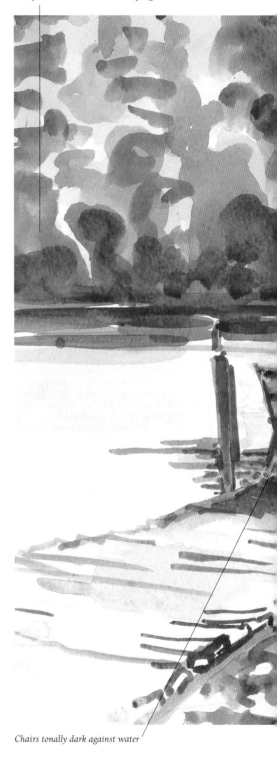

Modified trees shown as masses of lights and darks

Chairs tonally dark against water

down into the water to create the reflections. As these moved further from the bank they became lighter in colour.

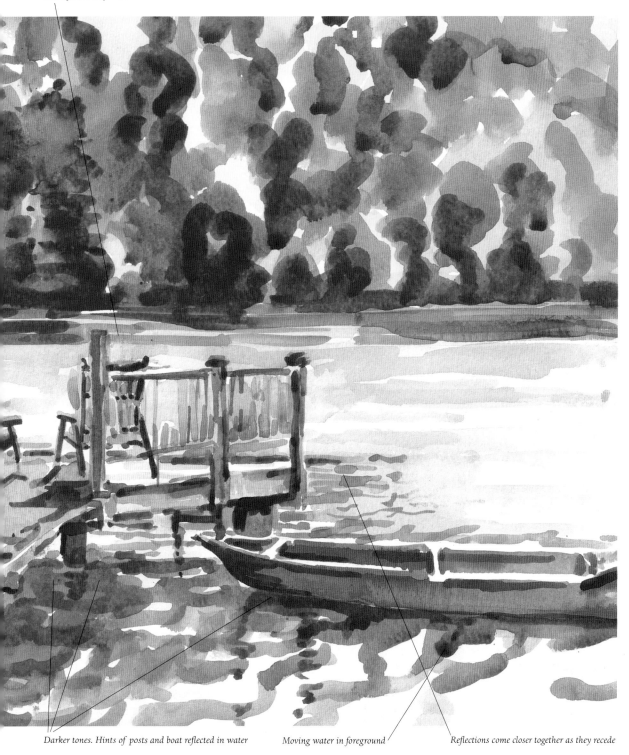

Still reflections of trees

Darker tones. Hints of posts and boat reflected in water

Moving water in foreground

Reflections come closer together as they recede

4 The broken reflections in the water beneath the jetty were added, except in the area of the boat. This was added last, with areas along its edge retained as the white of the paper.

Flowers

There are numerous ways of painting flowers, ranging from the precision of botanical illustration to soft, blurred images on damp paper. Whichever technique you use, it is always sensible to draw the flowers first as this will help you to analyse and understand their components and structure.

The traditional approach to painting flowers derives from botanical illustration. In such paintings, detail and description were paramount, as their purpose was primarily to allow the viewer to identify all the different species depicted. This type of painting therefore represented a method of recording information, as well as making a work of art.

However, the advent of the camera meant that records could be made very accurately and instantaneously with photographs, and this – along with influences from different cultures at the end of the 19th century – has led to many new approaches towards painting flowers in watercolour.

When working in the traditional manner, artists generally begin by drawing the subject very precisely in pencil. The flowers are then painted in layers – with the paint left to dry in between – working from the lightest tones through to the darkest.

When one concentrates on the details, as in this approach, the resulting paintings can be very beautiful as well as highly descriptive. However, flowers painted in this way do lack the element of spontaneity and therefore often fail to capture the 'essence', which is linked with their shape and colour.

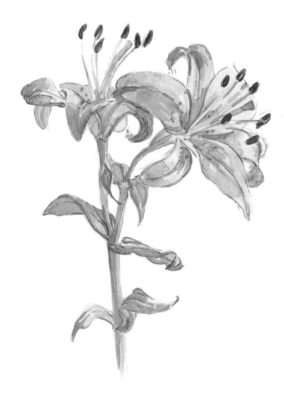

EXERCISE – PAINTING SPONTANEOUSLY

Try the following approach to painting the same lilies as those shown on page 62. Here you will be concentrating more on capturing the essence of the flowers, the main focus of interest being their colour and shape, rather than the details. This alternative approach exploits the medium of watercolour, using it to convey an impression of the flowers.

Stage one

Try 'drawing' with your paintbrush, using it like a pencil. Start with the colour (a mix of cadmium yellow, cadmium red and light red) at full strength and allow it to move about, then flood the petal shapes with colour. Blot with a soft tissue to lighten areas as necessary, then leave the paper to dry before adding details such as the purple stamens (Winsor blue and light red) and the stalk (Hooker's green dark with a touch of cadmium yellow).

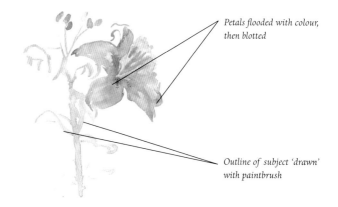

Petals flooded with colour, then blotted

Outline of subject 'drawn' with paintbrush

Details added when paper dry

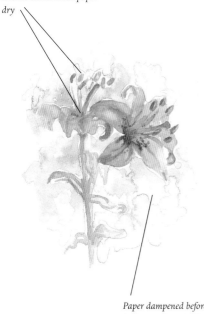

Paper dampened before background wash of colour added to set off flower

Stage two

Add further details, such as those on the stalk, and to pick out darker tones on the petals. Dampen the paper around the flowers, and use a contrasting wash to set them off.

With this method you have only used one layer of paint, the result of which is that the colours stay fresh and glowing. You could add further detail later, once everything is dry, if you wish.

TIP

Be cautious with your use of the staining pigments until you are fairly confident (see page 33).

- Staining colours include sharp, cool reds.
- Cool greens such as Hooker's green dark and Winsor green will stain. However, viridian, although a difficult green for beginners to use (see page 42), does sponge off easily.
- Most of the blues – except Winsor blue – are easily removed.

A COLOUR PALETTE FOR FLOWER PAINTING

When painting flowers, you may wish to use a more extensive range of colours than is generally used for landscape painting. Some of the colours rarely used by landscape painters, but which are essential for flower painters, include the following.

Permanent rose

This beautiful, sharp, transparent pink is found in many flowers. It may also be mixed with blues to make lovely purples.

Permanent rose + ultramarine + Winsor blue + cerulean

Winsor purple

This is a sharp, clear ready-mixed purple. Combined with viridian or Hooker's green dark, it makes a very rich dark.

Winsor purple + viridian + Hooker's green dark

Hooker's green dark

This colour makes a lovely base for many other greens. You can also mix it with yellows or blues to extend the range of greens without producing 'muddy' effects.

Hooker's green dark + cadmium yellow + Winsor blue

In addition, by mixing a touch of permanent rose or rose madder into Hooker's green dark, you will be able to achieve lovely transparent darks.

Hooker's green dark + permanent rose + rose madder

Aureolin yellow

More transparent than most yellows, this rather expensive pigment helps to prevent heaviness and opacity.

Aureolin yellow with a range of other yellows

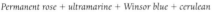

USING COLOUR FREELY

Try painting your flowers directly and spontaneously, the only 'drawing' being done with your paintbrush. Use strong full colour – if you wish to lighten any areas, gently blot them with soft tissue. Experiment with dropping one colour into another, working wet-in-wet (see page 12).

Daffodil

This daffodil was drawn in lemon yellow, the colour was then floated over and the lighter petals blotted off. The area inside the trumpet was painted in the darker colour of yellow ochre. With the neck still wet, a touch of Hooker's green dark was added with a little cadmium yellow The back of the flower was painted, blotted and drawn again.

The study below and those on the opposite page demonstrate how colour can be used simply but very effectively on some of our common flowers. An English size 8 brush was used for the studies; a French size 4 with a good point would also be suitable.

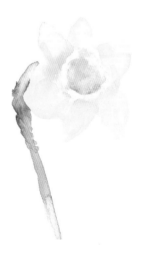

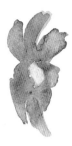
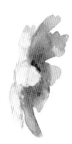

Cosmos

1. *Flower centre painted first in cadmium yellow and lemon yellow, and allowed to dry. Flower shape then 'drawn' in permanent rose, using a paintbrush, and the wet colour washed across the petals. Touch of cerulean blue dropped in while paint still wet.*

2. *Before the paint started to dry, the lighter sides of the petals were blotted with soft tissue.*

3. *When all was dry, the petals were defined with a little more paint, and the stalk (a pale mix of Hooker's green dark and cadmium yellow) was included. Finally, the dark stamens in the flower centre were added.*

Chrysanthemum

1. *Flower centre painted first in cadmium yellow and lemon yellow, and allowed to dry. Petals then 'drawn' in lemon yellow.*

2. *More water added to the paint, and this dilute mixture floated over the petals. Colour lightened a little where necessary by blotting with a soft tissue, then left to dry.*

3. *Petal shapes defined with more paint. Darker tones included a touch of yellow-green; for the slightly darker yellow, yellow ochre was used. Finally, flower centre was developed and the stalk (a mix of aureolin yellow and a touch of Prussian blue) was added.*

Rose

1. *Cadmium yellow, the underpinning colour, was used to 'draw' the shape of the flower, and the second colour was then floated across.*

2. *With paint still slightly damp, orange-pink tones in the petals (cadmium yellow with a touch of permanent rose, and Winsor purple for the purple tinge) were added. Paper then left to dry.*

3. *Petals were drawn out slightly stronger, and hard edges softened with a touch of water. When dry, a mix of cadmium yellow plus a touch of Prussian blue was used for the leaves and stalk.*

USING TONE – PAINTING WHITE FLOWERS

Light and shade may be used to create a sense of three dimensions in flower painting. This can be very useful when painting white flowers, where, traditionally in watercolour, the white of the paper stands for the white areas within the flowers themselves. To draw out white flowers from a white background, you will need to exploit the lights and darks playing on the flowers, and to use the colour and tone of the background to set them off.

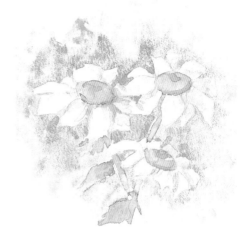

It is wise to use a colour to paint the tones in a white flower, as the shadows are rarely a true grey. This is demonstrated in the picture to the right. Here the shadows and the tones on the petals were painted to bring out their form. A coloured wash was then added around the flowers, to make them stand out from the white background.

Another way of painting white flowers is to use masking fluid, to protect the white areas from washes subsequently laid over the top. This technique has been used in the example below.

TIP

Before putting on the background colour, gently dampen the paper behind the flowers with water. The colour that you use here will then gently drift away, and you will avoid hard edges.

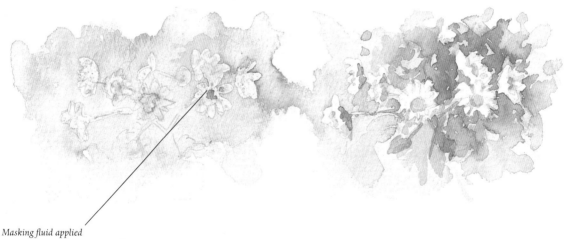

Masking fluid applied to flowers

Stage one
A simple pencil sketch was made, and masking fluid was applied over the areas of the flowers. A wash of Payne's grey and cobalt blue was then floated over the whole area and left to dry.

Stage two
The masking fluid was removed by rubbing gently with a finger, and the flowers further developed.

SNOWDROPS

For this painting, the effect of the light was studied carefully. Notice how the snowdrop on the left appears dark against the background, whereas the other snowdrops are lighter than the background. The light is coming from the right, as is clearly shown by the direction of the shadow.

COLOURS
- **Reds** – burnt sienna and sepia
- **Yellow** – cadmium yellow
- **Blues** – Payne's grey and cobalt blue
- **Green** – Hooker's green dark

PAPER
- Bockingford Not, 300 gsm (140 lb)

BRUSHES
- English sizes 8 and 2 (mixed nylon and hair)

This subject was drawn carefully in pencil first. The snowdrops in the centre, and the highlights on the glass and in the shadow, were initially masked out with masking fluid.

The background wash (mixed from Payne's grey and cobalt blue) was then floated over, and taken around the unmasked, overhanging snowdrops. Once this wash was dry, the masking fluid was removed and the painting developed, with full use made of light and shade to suggest the forms of the flowers. The greens were made from mixes of Hooker's green dark and cadmium yellow.

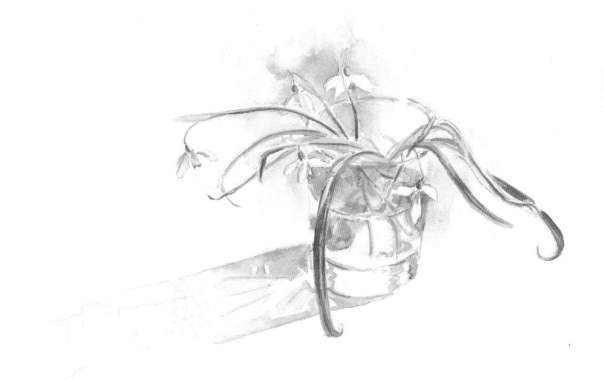

Demonstration

Combining white and coloured flowers

In this painting of cornflowers and daisies, masking fluid protected the white daisy petals from the subsequent overall wash.

COLOURS
- **Red** – burnt sienna
- **Yellow** – cadmium yellow
- **Blues** – ultramarine, cobalt, cerulean, and Winsor blues, and Payne's grey
- **Green** – Hooker's green dark

PAPER
- Saunders-Waterford Not, 300 gsm (140 lb)

BRUSHES
- French size 4 and Rigger size 2

Method

1 The daisies were first lightly drawn in pencil, and the petal areas carefully covered with masking fluid. Once dry, a wash of cobalt, cerulean and ultramarine blues was applied freely over the whole surface. When dry, a glaze of Hooker's green dark and Payne's grey was applied.

2 On the dry paper the cornflowers were then painted in mixes of ultramarine, cobalt, cerulean and Winsor blues. Before painting the containers, close observation was needed of how they were affected by the light. They were painted working from light to dark (see pages 82 and 86).

3 The background was redampened, and a transparent glaze of Hooker's green dark was washed over it. A few extra flowers were added on the damp background, giving a smudged and more distant effect.

4 When dry, the masking fluid was removed and the daisies were developed.

> **TIP**
>
> As you gain confidence, you may like to miss out the initial pencil drawing with a composition such as this, and simply apply the masking fluid directly in the appropriate areas.

Cornflowers painted in mix of blues

Backruns created wet-in-wet, with paper unevenly wetted

'Calligraphic' work painted with rigger brush

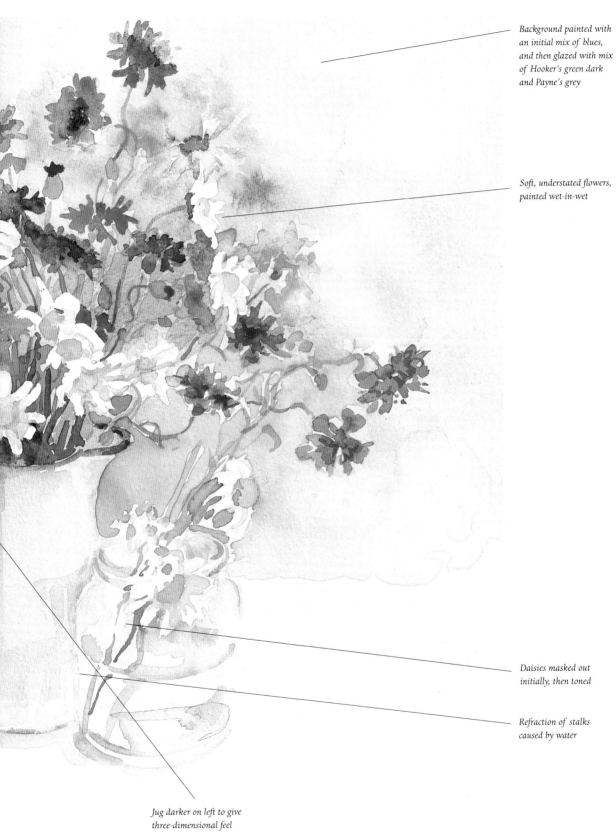

Background painted with
an initial mix of blues,
and then glazed with mix
of Hooker's green dark
and Payne's grey

Soft, understated flowers,
painted wet-in-wet

Daisies masked out
initially, then toned

Refraction of stalks
caused by water

Jug darker on left to give
three-dimensional feel

PAINTING FLOWERS *IN SITU*

When painting flowers in their natural environment, you will need to take a different approach from that used when painting flowers in a vase immediately in front of you.

In the same way as when painting a mass of trees or bushes (see page 39), the key rule is to avoid concentrating on any detail in the flowers, but to look instead at their overall, generalized shape and their appearance against the background. It is very easy to overwork flowers, and not to take the background into consideration.

EXERCISE – NEGATIVE PAINTING

To practise the idea of depicting generalized flower shapes against a background, try painting the delphinium shown below. An English size 8 brush was used here. A French size 4 brush with a good point would also be suitable, or a rigger brush could be used for the calligraphic brushmarks in the foliage.

TIP

To help you with this, try to think more of drawing out the shapes of the flowers by painting the background, rather than of painting the flowers themselves. This technique is often referred to as 'negative painting'.

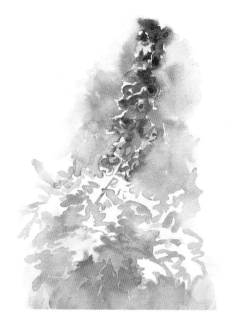

Stage one
Paint the general colour and shape of the flower on to dry paper, using a mix of ultramarine, cobalt blue and cerulean blue – this should be stronger at the top, and more diluted towards the base of the flower. Dampen the background, and put in a very soft, light, yellow-green wash behind the flower. Allow the paper to dry.

Stage two
Define the shapes of the flowers and lighter-coloured leaves by painting the darker colours and tones behind them, using Hooker's green dark with touches of the blues – these are the shadows within the foliage. This is 'negative painting' – in other words, you are painting the darker background in order to define the shapes of the flowers, rather than painting the shapes of the flowers and foliage themselves. Wet the background behind the flower so the colour will softly diffuse and wash on a strong dark green. This colour will throw out the shape of the delphinium.

When everything is dry, you may need to invent some marks to suggest further detail as shown here. These marks are a little like calligraphic 'squiggles'.

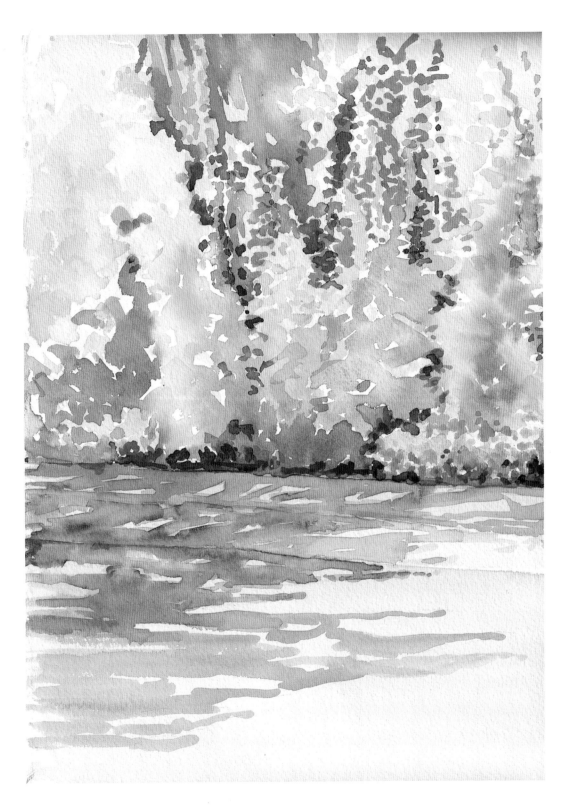

In this almost abstract painting, the
flowers and foliage have been defined largely
by painting the shadows that lie behind and
below them.

A POPPY FIELD

You must take care when tackling a painting like this to preserve the delicate colour of the flowers. In stages three and four (opposite), the green-yellow background was carefully painted around the flowers. Had the red poppies been painted on top of the green, they would have been dulled by this underlying colour.

COLOURS
- **Reds** – cadmium red and rose madder
- **Yellows** – raw sienna and cadmium yellow
- **Blues** – cobalt blue

PAPER
- Saunders-Waterford Not, 300 gsm (140 lb)

BRUSHES
- English size 2
- French size 4

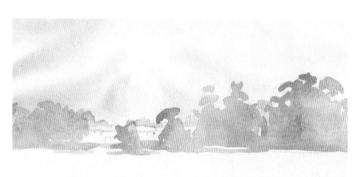

Stage one

A light pencil sketch was made of the trees, the farmhouses peeping through them and a few poppies in the foreground. A raw sienna wash was then applied over the paper. While still wet, cobalt blue cirrus clouds (see pages 32–3) were drawn through the paint.

When all was dry, the trees were painted. The light source coming from the right was noted, and the trees painted all at once, working from light to dark. The trees, at the back of the far field, were created from a mix of cobalt blue and cadmium red (purple); the slightly nearer trees were a mix of cobalt blue and raw sienna (green).

Stage two

A little more depth of colour was added to the trees, and the roofs of the houses in the distance (mixed from cadmium red and cobalt blue) were put in. The foreground was rewetted, and soft reds – mixes of rose madder and cadmium red – were floated where the poppies were to be added. The cooler red was used in the background, and the warmer in the foreground. Care was taken to ensure that the bands became larger as they entered the foreground, as this also helped to give a sense of depth and scale. Everything was then left to dry.

Stage three

The 'body' of the farmhouses was added, and the poppies were painted in more detail, with patches of a darker rose madder and cadmium red mixture used in the foreground. When this was dry, the green of the field – a mix of cobalt blue and cadmium yellow – was painted around the poppies. This technique of 'negative painting' ensured that the poppies remained bright and red. The paper was then left to dry.

TIP

In the final stages of a painting like this, take care not to overwork the foreground or you will lose the delicacy of the watercolours.

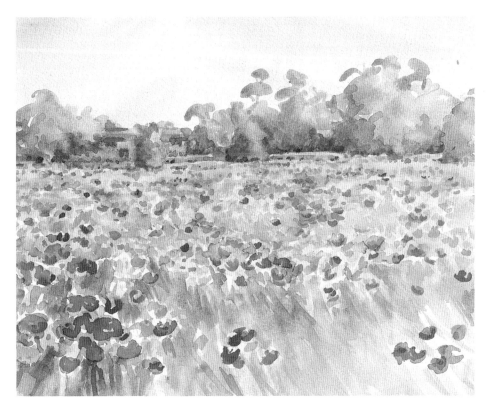

Stage four

The poppies were still just a little too pale, so these and the farmhouses were given another wash of a slightly deeper pink. The poppies in the foreground were then developed further, along with some of the foreground grasses – some of the grasses were painted a fairly strong colour, to emphasize the poppies and to bring the foreground closer.

Selected poppies were painted in greater detail, and further darks and shadows were added around them in order to throw out their colour. Finally, the distant trees were reworked by strengthening the darker tones.

GARDEN SCENE

Here you can see how the painting of this garden was gradually built up by working from light to dark, which is generally the best way to approach a subject with a number of different elements such as this.

Stage one

After some initial drawing, the white daisies were masked out with masking fluid. The patches of pink and red flowers, and the blue shirt (the focal point), were the first colours to be established. When these were dry, loose washes of the lightest colours (aureolin yellow and cadmium yellow, with some cerulean blue added in the foreground) were floated over the paper, around the flowers and shirt. These washes would eventually represent the lightest colours and tones within the picture.

COLOURS

- **Reds** – cadmium red, permanent rose, rose madder and light red
- **Yellows** – yellow ochre, aureolin yellow and cadmium yellow
- **Blues** – Prussian blue, cerulean blue, ultramarine and cobalt blue
- **Green** – Hooker's green dark
- **Purple** – Winsor purple

PAPER

- Saunders-Waterford Not, 300 gsm (140 lb)

BRUSHES

- English size 2
- French sizes 4 and 1

Stage two

Darker tones and colours were added next, not only for some of the foliage and other elements (such as the shadowed side of the central house, and the roofs of those on either side), but for the shadows and darker tones within and behind the foliage. Once again, therefore, the negative shapes of the background were used to define the shapes of the foliage and other details such as the poppies.

Masking fluid applied to daisies

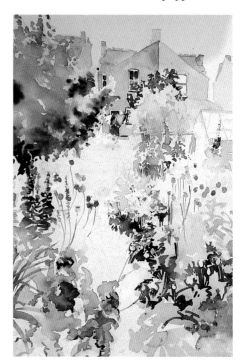

Stage three

Gradually these darker tones were extended to define more of the foliage, to add further areas of shadow – such as on the lawn and at the edge of the path – and to pick out details such as paving stones.

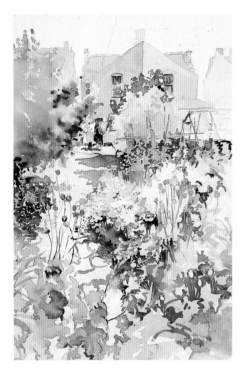

Stage four

Finally the masking fluid was removed from the daisies, and these areas modified with further colour. The darks in the area of wall behind the washing line were strengthened to emphasize the focal point.

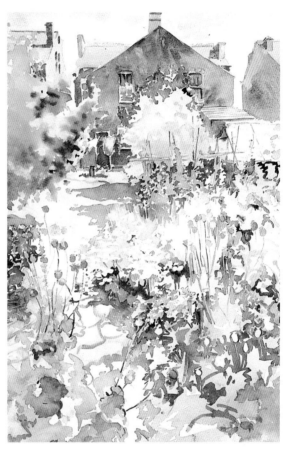

Detail of foliage

Here you can see how the 'negative' parts of the picture (the background tones and shadows) have been used to strengthen some of the foliage and the white shapes of the daisies. Notice that some of these darker tones are actually purple, which gives depth to the darks, while adding an attractive colour.

PAINTING WITH A MULTI-COLOURED BACKGROUND

The background of a flower painting, or indeed a painting of any subject, can greatly enhance the overall effect. This is another area in which watercolours really come into their own, as their transparency produces some wonderfully subtle results. When several colours are used in a background, as in this painting, handle them carefully so that the transparency is not lost.

Stage one

The positions of the two containers were very lightly plotted with a pencil. The background was then sponged with water, and colours which echoed those of the flowers – yellow ochre, cadmium orange and light red mixtures – were floated over the paper. Some areas were left unpainted.

COLOURS
- **Reds** – rose madder, cadmium red and light red
- **Yellows** – yellow ochre and cadmium yellow
- **Blue** – cobalt blue
- **Green** – Hooker's green dark
- **Orange** – cadmium orange

PAPER
- Saunders-Waterford Not, 300 gsm (140 lb)

BRUSHES
- English size 8
- French size 4

TIP

At this stage of a flower painting, remember to think of the subject as an abstract, and to pay attention to the balance and attractiveness of the soft shapes of colour.

While the paint was still wet, a dampened soft tissue was used to blot the lighter areas within the glass container back to the white paper.

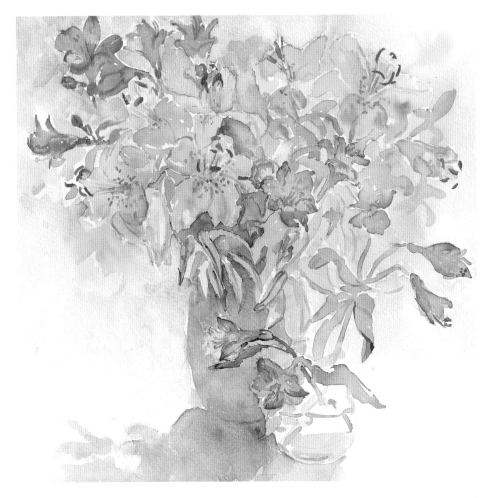

TIP

Always carry out any overpainting or glazing with very wet, diluted colour. If you use colour that is too strong it may block the underlying colours, and will appear heavy and opaque. To be successful, the underlying colours should shine through the subsequent glaze.

Stage two

When the paper was dry, the flowers were drawn and painted in colour, using a brush. The foliage was then added, followed by the containers. When everything was dry, the flowers were developed further. This was done selectively, as it is very easy to overwork a picture at this stage (if some flowers are left understated, the viewer's imagination will fill in the missing details).

Once everything was dry, the background was repainted with a wash of a soft, mixed grey (a mixture of light red, cadmium red and cobalt blue). This had the effect of neutralizing the background, and throwing out the colours of the flowers. Some flowers were overpainted with the wash, to make them softer and appear further away.

Close-ups showing the range of overlying colours used.

Demonstration

Poppies with tinted background

The poppies and overall composition were lightly drawn with pencil first. The flowers were then painted working from light to dark; some were blotted afterwards with a dampened soft tissue to lighten the tones.

COLOURS
- **Reds** – cadmium red, Winsor red, permanent rose and rose madder
- **Yellows** – cadmium yellow, aureolin yellow and yellow ochre
- **Blue** – cobalt blue
- **Green** – Hooker's green dark

PAPER
- Bockingford Not, 300 gsm (140 lb)

BRUSHES
- English sizes 12, 8 and 2
- Rigger size 2

Method

1 The composition was lightly drawn in pencil first. The flowers were then painted on to the dry, white paper, with their vibrant reds created with mixes of all the reds and touches of aureolin yellow. This was done working from light to dark, with areas blotted where necessary to lighten them. The flowers were then left to dry.

2 The rigger brush was used 'oriental-style' – with more of a wrist movement – to paint the foliage, which comprised mixes of Hooker's green dark, along with touches of cadmium yellow and cobalt blue.

3 The paper was dampened, and a few more poppies and some foliage, made from more dilute mixes of the original colours, gently dropped in. This produced

soft, diffused edges, and gave the poppies the appearance of being further away.

4 The background looked a little hard, so the paper was dampened with a brush and water, and a very gentle, transparent wash of aureolin yellow, with touches of cadmium yellow and yellow ochre, was

Flowers worked from light to dark

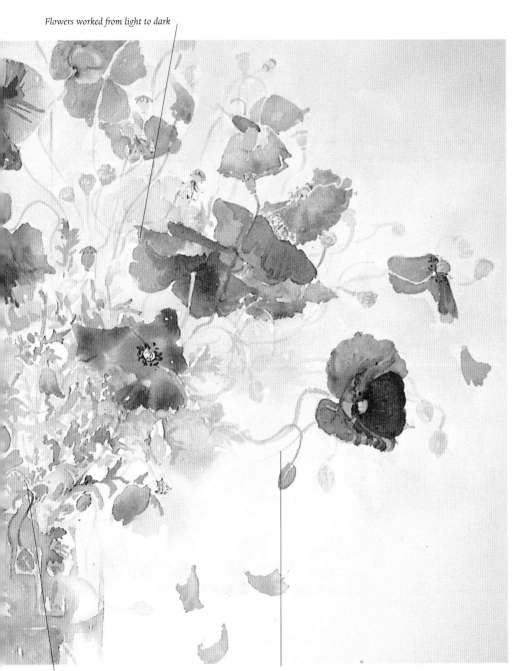

Rigger brush used lightly to paint foliage *Poppies painted wet-in-wet so they diffuse softly*

floated over and around the flowers and
foliage. Care was taken to add water at
the edges of this wash so that it softly
floated away, leaving no hard edges.

Still Life

A vast range of subject matter is included under the 'umbrella' of still life, and it is great fun to do. It also has the advantages that you can paint indoors and that, if you use inorganic objects, they will stay just as they are, however long you leave them.

TIP

- Before you start painting any object, observe where the light is coming from, and how it falls on the subject. Then concentrate on painting the colour and texture.

- When everything is dry, paint on the shadows, softening any hard edges with touches of clean water. The shadows should be transparent, allowing the original colour to shine through.

- At times you may find yourself painting the shadows while everything is still wet. This is a very fast way of painting, but is more difficult to control.

PAINTING SIMPLE ORGANIC OBJECTS

A good way to begin in still life is by painting some simple objects on their own, to practise techniques that can be used. Start by painting the fruits and leaves shown here, and then experiment with other organic objects. An English size 8 brush was used here; a French size 4 brush with a good point would also be suitable.

Painting a green apple

1. *Lightly pencil in the outline of the apple. Float a wash of yellow-green (mixed from cadmium yellow and a touch of Hooker's green dark) over it, and leave to dry.*

2. *Draw out the centre of the apple and the stalk, and paint the shadowed side of the apple, adding a little Prussian blue to the previous mixture. Soften any hard edges and paint the shadow on the table, allowing it to drift into the still-wet shadowed side of the apple. Finally, create the highlight on the apple by gently rubbing away the colour with a dampened, soft tissue.*

Painting a yellow-and-red apple

1. *Lightly pencil in the outline of the apple. Paint a wet-in-wet wash of cadmium yellow and orange-red (cadmium red and alizarin crimson) over it, and leave it to dry.*

2. *Paint the shadowed side of the apple with a deeper red (using more alizarin crimson), and draw out the centre of the apple. As with the green apple, introduce the shadow using alizarin crimson and a touch of Hooker's green dark. Create the highlight by rubbing with a dampened, soft tissue.*

Painting leaves

Painting leaves, particularly in their multitude of autumn colours, can be great fun. It provides an opportunity to exploit working wet-in-wet, creating textures and colours without too much worry, as an unintentional blob surprisingly often helps the texture of the leaves.

1. *Lightly draw the leaf shape in pencil first. Drop colours such as cadmium yellow, raw sienna, light red and sepia on to the drawing working wet-in-wet, and allow them to dry.*

2. *Add further, deeper mixes of colour, and include the shadow under the leaf. Soften any hard edges with touches of clean water.*

1. *Lightly draw the leaf shape in pencil, then apply mixes of the same colours used above. To create the turn-up on the leaf, try blotting that area with a dampened tissue and then drop in some stronger colour behind it to 'throw out' the edge.*

2. *Paint darker tones over the leaf, 'drawing out' the light-coloured veins with the darker colour behind them. Add the shadow beneath the leaf – this will have the effect of anchoring it to the table surface.*

TIP

Do not become sidetracked into detail unless you want to be very descriptive. It is better just to suggest details such as veins and to concentrate more on the general colours and shapes of the leaves. As with all subjects, it is also important to decide where the light is coming from. Establishing this before you start to paint will help you to see the darker tones and the direction of the shadows.

Making an autumnal still-life study, such as this simple picture of apples and leaves, will allow you to use a range of wonderfully warm, bright russet and orange tones.

These might include cadmium yellow, raw sienna and yellow ochre; light red, alizarin crimson, burnt sienna, burnt umber and sepia; and perhaps one blue, such as ultramarine or Prussian. There is very little blue in autumnal colours, but it may be useful to make colourful greys and darks.

PAINTING SIMPLE INORGANIC OBJECTS

As inorganic objects do not move, they make excellent material for practising still-life painting. Start with simple objects, such as the coarsely textured pots shown below.

Painting a textured pot
In this study the complementary colours ultramarine and light red are mixed together to make a blue/brown grey. Both colours are very grainy, which assists with the texture of the pot.

T I P

Coarse textures can be depicted very easily if you use grainy paints – experiment with a range of pigments to see which work best (see also page 14). Remember that you can achieve different greys by using complementary colours.

 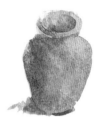

1. *Lightly draw the pot in pencil. Wash a mix of ultramarine and light red over the pot and its shadow, and leave it to dry.*

2. *Darken the shadowed side of the pot with a mix of the same colours, and draw out the shape of the top. Soften any hard edges with touches of clean water, or by blotting with a gentle touch of dampened, soft tissue. Then leave the paper to dry.*

3. *Add touches of the few darkest tones, and once again soften the edges with touches of clean water, or by blotting.*

Painting a plant pot
As with the sketch above, it is important to observe how the light affects this pot before starting work.

T I P

If you use a tissue to create highlights and the effect looks slightly clumsy, you can improve it with a brush while the paint is still damp.

1. *Make an initial pencil drawing, and then apply a wash of burnt sienna over the plant pot and its shadow. While this is still wet, remove the parts that catch the light with a twisted piece of soft tissue. Leave the paper to dry.*

2. *Keeping in mind the direction of the light, add the darker tones – a mix of burnt sienna and ultramarine. Soften any hard edges with clean water, or by gently blotting with a soft tissue, and then leave the paint to dry.*

3. *Add the darkest tones of all and, once again, soften any hard edges with touches of clean water.*

Painting a white bowl

This white bowl appears as predominantly grey. Its surfaces are affected by light, which creates different tones, shadows and highlights. When a white object such as this is placed on a sheet of white paper it becomes obvious that what defines the object and separates it from its background is the light and shade falling across it.

Masking fluid applied to protect highlights around rim and base

1. *Draw the bowl lightly in pencil, and then protect the sparkling white highlights with masking fluid. Apply a grey wash mixed from ultramarine and burnt sienna over everything, and leave the paper to dry.*

2. *Paint the intermediate, middle tones in a slightly darker mix of the same colour. Soften hard edges with touches of clean water, or by blotting, and leave to dry.*

3. *Add the darkest tones of all. When these are dry, remove the masking fluid by rubbing with a finger.*

TIP

If previously applied masking fluid has become a little hard and does not come away easily, soften it by rubbing it gently with a piece of dampened, soft tissue.

EXERCISE – SETTING UP AND PAINTING A STILL LIFE

Set up a composition such as this one with different sized objects. Group them together for a better effect, with the tallest and biggest at the back.

First of all draw the set lightly, using the pencil with rough, fluid movements to get an approximation of the composition.

Then go to the centre and draw more accurately by comparing one object with another. Always aim to start from the centre and work outwards. The second object could be taller, shorter or in front of the other one, and so on. It is important that you use each pencil mark as a reference point for finding another part of the set.

COLOURS
- **Reds** – burnt sienna and light red
- **Yellows** – cadmium yellow and yellow ochre
- **Blue** – ultramarine

TIP

- Exploit the qualities of grainy paints – here they were used to help create the texture of the containers.

- All the colours used here are non-staining (see page 33). It is a good idea to use these when you are a beginner, as unwelcome hard edges can easily be softened with touches of water, a piece of dampened tissue or a hog's-hair (bristle) brush.

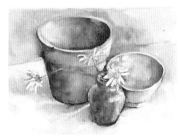

1. *Use loose, fluid pencil marks to get a rough idea of the set. Work from the centre outwards, continually comparing the position of each object with another.*

2. *Having placed the objects, add in a little more definition and detail.*

3. *Mask out white flowers. Float over burnt sienna, light red and ultramarine for backdrop and flower pot. Use a dilute version with more ultramarine and less burnt sienna for table, vase and bowl.*

CHERRIES ON A PLATE

With their wonderful array of rich colours, cherries are an excellent subject for still life.

Drawing the cherries

Having lightly suggested the area of the plate and cherries, carefully draw one cherry. When you have done this, draw another cherry in relation to the first – maybe a little to the left or right, behind or in front of the first cherry. Look at the

relationship of these two, and use them as 'reference points' for the third cherry. In the same way, gradually move on to the other cherries. Then draw in the plate's position with reference to them.

Use the method above, working from the cherries and from the inside of the plate. Gradually move outwards, using anything you have already drawn as a reference point for the next object.

TIP

Do not start with the plate and then try to fit in the cherries. You will have to guess the size and shape of the plate, and it will only be as good as your guess.

1. *A quick, light suggestion of the set is made.*

2. *The cherries on the plate are more carefully drawn, each placed in relation to the next.*

TIP

Once you have established one object, never draw the others standing 'alone' – always draw a new object by referring to something already drawn. Using this method will help you to become very accurate in your drawings.

3. *By referring to these, the other cherries, and the edges of the plate, are gradually included.*

4. *The cherries on the table are drawn in more detail, with their sizes and positions determined by what has already been drawn.*

For the painting itself (see opposite), work also began in the centre and moved outwards. The highlights on the plate were masked out initially. The lightest colours in the cherries were established, and then those in the plate and background. The subject was developed further, and shadows added beneath them.

TIP

Make the darker tones simply by using a greater proportion of pigment to water than was used for the lighter colours.

Painting the cherries

Use a range of reds, both cool (for example, rose madder and alizarin crimson) and warm (such as cadmium red, light red and burnt sienna). You could also add a touch of purple. Experiment with using the deeper, cooler reds or purple for the darker parts of the cherries, and try making them even darker with a touch of sepia.

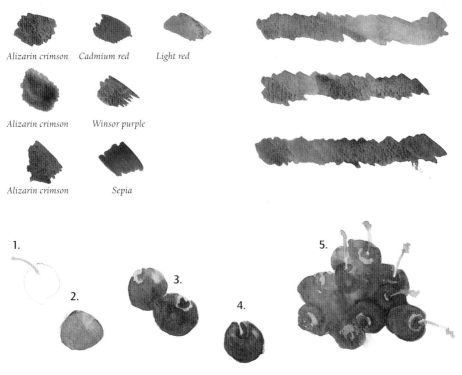

Alizarin crimson *Cadmium red* *Light red*

Alizarin crimson *Winsor purple*

Alizarin crimson *Sepia*

1.
2.
3.
4.
5.

1. Sometimes the stalk is painted first.
2. A light wash of warm red is applied, very gently blotted and left to dry.
3. The richer, darker tones are added, and the general shape of the cherry is drawn.
4. The stalk is drawn out with a wet hog's-hair (bristle) brush and then painted.
5. Additional highlights can be produced by removing paint while still damp with a soft tissue or a hog's-hair (bristle) brush.

TIP

When painting a group of cherries, try applying a wash over them first. When this is dry, develop the individual shapes.

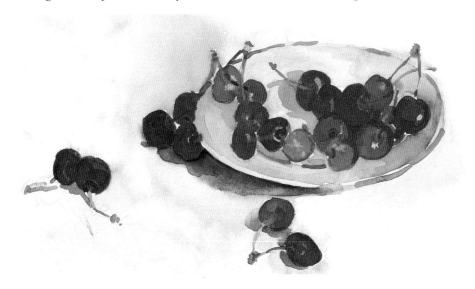

PAINTING PLAIN GLASS

When painting glass, you are really painting what you see through it, as well as any distortions, and light and shade effects. The light will create sparking highlights where it falls across and catches on the glass, as well as a range of tones from light to dark.

EXERCISE – PAINTING A SIMPLE TUMBLER

To keep this simple, place the tumbler on a sheet of white paper and stand a piece of white paper or card behind. This will enable you to really see the transparency of the glass, and the way it is affected by the light.

Masking fluid applied to protect highlights around rim and base

1. *Lightly draw the tumbler in pencil. Apply masking fluid over the bright, sparkly highlights, to keep them clean and white. Once this is dry, paint a wash of grey mixed from Prussian blue and sepia over the glass and the background and leave to dry.*

2. *Paint the middle tones of grey – seen in the glass, the background and on the table – using mixes of light red and cobalt blue.*

3. *Add the darkest tones as final touches around the rim and base of the tumbler. When dry, remove the masking fluid by rubbing gently with a finger.*

TUMBLER, WATER AND PAINTBRUSH

Having painted the tumbler with a white background, progress to a tumbler of water containing a paintbrush, positioned on a table with a coloured board or cloth behind it. Notice how unexpectedly the colours are picked up, and how the paintbrush appears to be distorted as it enters the water.

Masking fluid applied to protect highlights on tumbler and in water

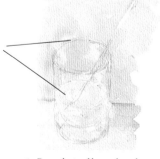 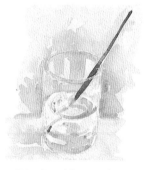 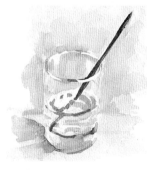

1. *Draw the tumbler, and mask out the highlights as above. Paint light washes of the background colours – light red and cobalt blue – over and around the tumbler, and leave them to dry.*

2. *Paint the middle tones of grey, including those within the tumbler, and on the background and table, using mixtures of light red and cobalt blue. The dark handle of the paintbrush is simply a slightly thicker mix of the two colours; the gold metal is cadmium yellow.*

3. *Add the darkest tones of all, and then remove the masking fluid. Soften any undesirable hard edges with touches of water, a soft tissue or a hog's-hair (bristle) brush.*

PAINTING COLOURED GLASS

Painting coloured glass is not very different from painting plain glass and the same principles will apply

For your first attempt, set a coloured bottle on a white surface against a white background. You will then clearly see the glass colours and all the different tones.

To echo the effect of glass, use smooth, transparent colours such as viridian, sepia, rose madder and Winsor blue. Winsor blue is a staining colour (see page 33), and once dry will not sponge off, but it is a beautiful, clear blue, and mixes well with viridian or an umber yellow to recreate glass colours.

TIP

Glass often has a hint of yellow in it. However, with the exception of aureolin yellow (see page 64) the yellows do tend to be rather opaque, so use them in moderation and remember that the amount of water you use will control the transparency.

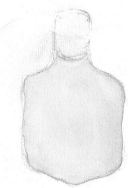

1. *Draw the shape of the bottle, and wash over a pale transparent mix of viridian and cadmium yellow. Paint a grey mix of sepia and Winsor blue on the background and the surface on which the bottle sits, and leave everything to dry.*

2. *Paint the middle tones, including the green-ish shadow behind the bottle, leaving touches of the first colour to stand for the highlights. Make the colour lighter in places by blotting with a dampened, soft tissue.*

3. *Add the darkest tones of all. These are a mix of viridian and sepia, a good example of how complementaries may be mixed together to make colourful darks (see also page 28).*

TIP

On another painting of this type, you could try mixing viridian with rose madder – these will make another beautifully rich, transparent dark.

STILL LIFE WITH BOTTLE, GLASS AND BOOK

This small still life shows once again the importance of recognizing that with glass you are really painting what you see through, underneath and behind it.

COLOURS
- **Red** – burnt sienna
- **Yellow** – raw sienna
- **Blue** – Prussian blue
- **Green** – viridian

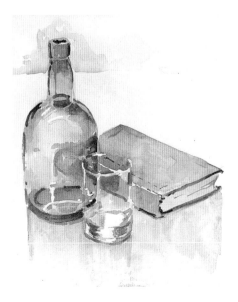

The objects were lightly drawn in pencil, and the highlights masked out. The book was painted first (using burnt sienna with a touch of Prussian blue), with care taken to paint any distortions seen through the glass and bottle. The bottle and glass were then painted (using raw sienna, viridian and Prussian blue), working from the lightest tones through to the darkest.

PAINTING SHOES

Some of the most unlikely objects, from pieces of tree bark to Wellington boots, can provide interesting shapes, tones and textures for still-life studies. Try placing objects singly or in groups, and on a range of surfaces and against different backgrounds.

Shoes can be fascinating to paint, and their many shapes and materials provide endless variety. This exercise uses a pair of well-worn, patterned shoes.

COLOURS
- **Red** – cadmium red
- **Yellows** – yellow ochre and raw sienna
- **Blue** – cobalt blue

PAPER•
Saunders-Waterford Not, 300 gsm (140 lb)

BRUSH•
French size 4

Masking fluid applied around heel and sole of shoes, and on buckle

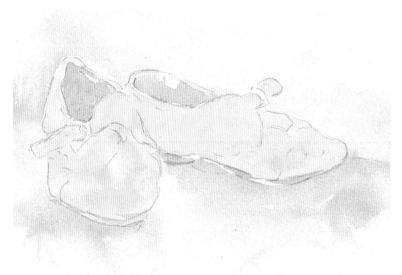

1 The shoes were drawn in pencil, and a few highlights protected with masking fluid. A light wash of cadmium red and a little raw sienna was painted over the shoes and allowed to dry.

2 A darker mixture of the same wash, with a touch of cobalt blue added, was used for the insides of the shoes and around the sole. A light, pink-purple wash was then painted over the background, around the shoes, and left to dry.

3 The details and buckles were picked out on the shoes, using a darker mix of the main colour. Further definition was added inside the shoes and around the soles. The light source was noted (it is coming from the left), and then the shadows within and beneath the shoes was painted. Finally, the masking fluid was removed and the newly revealed white areas modified.

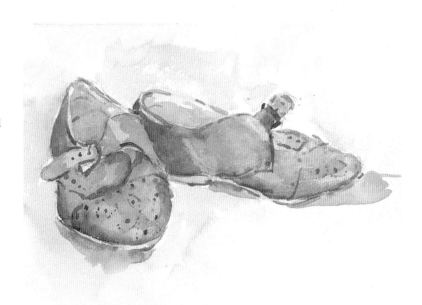

SHOES WITH LIGHT

The light effects in this painting, using tones, shadows and highlights, have been used to maximum effect.

After some initial drawing, a colour wash (mixed from rose madder and raw sienna) was painted over the paper. Parts of the paper were kept white to depict the bars of light falling across the room. When this wash was dry, the darker, stronger tones were added, using the same mixture with touches of sepia and cobalt blue.

Finally, on dry paper, a wash of a very soft burnt sienna was glazed over everything. This 'warmed' the picture, and softened the rather hard areas of light.

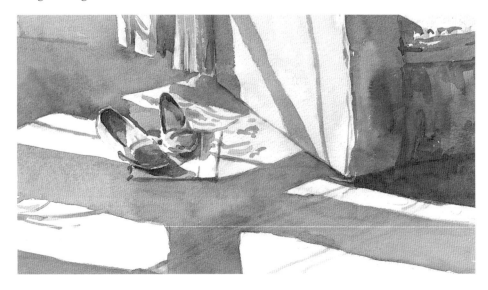

Demonstration

Spring flowers and cherries

In this painting flowers and still-life objects are combined and employ many of the techniques described in the previous pages.

COLOURS
- **Red** – burnt sienna
- **Yellows** – aureolin and cadmium yellow
- **Blues** – Prussian blue and ultramarine
- **Green** – Hooker's green dark
- **Purple** – Winsor purple

PAPER
- Arches Not, 300 gsm (140 lb)

BRUSHES
- English sizes 8 and 1
- French size 4
- Rigger size 2

Method

1 The minimum of composition was lightly plotted in pencil. Masking fluid was then applied over the white flowers and the highlights on the glass containers.

2 The paper was dampened with a sponge, and soft washes of aureolin yellow and cadmium yellow were floated over the paper. These were strongest in the areas in which the yellow flowers were to be painted, and were gradually thinned with water as they moved away. This ensured that there was not too much strong yellow in the areas where the purple-red cherries would be painted. The paint was then left to dry.

3 The yellow flowers were painted by 'drawing' directly with the paintbrush to achieve a fresh and natural result.

4 The painting was gradually developed by

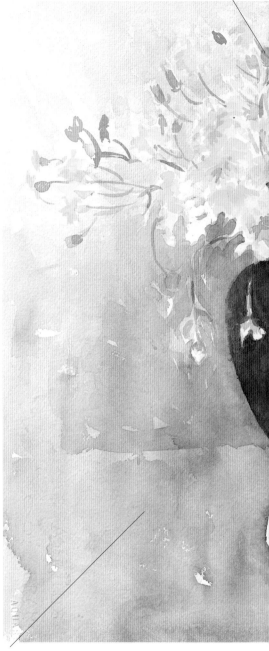

'Calligraphic' brushstrokes

Glaze of grey-purple over yellow wash

moving from flowers to foliage, using aureolin yellow, cadmium yellow, Prussian blue and Hooker's green dark. The earlier drawing of the containers and plate was then checked for accuracy. These, and the cherries, were then developed. The dark pot was painted with

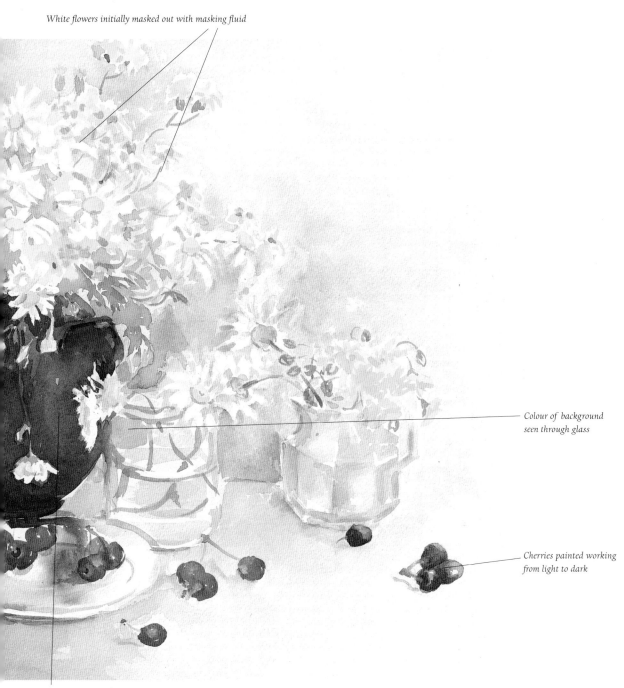

White flowers initially masked out with masking fluid

Colour of background seen through glass

Cherries painted working from light to dark

Grainy paint used to create texture

a mix of burnt sienna, ultramarine and Winsor purple.

5 Parts of the background were rewetted, and a further wash of dilute aureolin yellow and Winsor purple was floated over the original wash. This was also used to develop the shadows. The paint was kept dilute so that the original wash would show, but stronger behind the white flowers so that they stood out.

6 The masking fluid was then removed, and areas of the white petals modified.

CONCLUSION

I hope that the suggestions and advice given in this book will help to initiate your own adventure into watercolour painting. Whatever guidelines you follow, however, remember that there simply is no single road to travel, and no single approach to painting. In the end, what matters is the way in which any individual artist uses techniques, approaches and colours – some of which have been outlined here – to convey the excitement of what he or she sees.

The aim of this book has been to enlighten you about the basic techniques of watercolour. These should act as a 'springboard' for your own development as an artist, as you begin to work in your own unique style. As you become more experienced you will select and use your own techniques, seek out new approaches and experiment with form and colour. That, after all, is our art.

As with much of life, you will get out from watercolour painting what you put in. I hope that this book has indicated some new avenues through which to explore your own excitement about what you see.

INDEX

A

aureolin yellow 64, 87

B

backruns 35
basic techniques 16-19
blobs, dealing with 14
blotting off 13
blues 8, 33, 64
botanical illustration 62
bowls 83
brushes 9-10
 caring for 10
 flat brush 9, 39
 hog's-hair (bristle) brush
 10, 13
 mixed nylon and hair 9
 pure nylon 9
 rigger brush 9, 39, 44
 sable and squirrel brushes 9
 sizes 9
brushes, 'drawing' with 90
buildings 46-53
 painting from photographs
 47
 perspective 46
 'vanishing point' 46
 viewed 'straight on' 46, 52-3
burnt sienna 29

C

calligraphic brushmarks 15
candlewax, applying 13
cerulean blue 33
cherries 84-5, 90-1
clouds 32, 33, 34
coarse textures 82
cobalt blue 33
colour 20-3
 complementary colours 28
 merging 6, 17
 primary colours 20, 21
 receding 20, 44
 removing 35
 and tone, combining 30-1

'coloured' darks 28
composition 25

D

dark tones 28-9
 softening 38
diagonal lines 25
dirty, 'muddy' marks 35
drawing board 10

E

easels 11
equipment *see* materials
 and equipment

F

flower painters 8, 9
flowers 62-79
 chrysanthemum 65
 colour palette 64
 cosmos 65
 daffodil 64
 delphinium 70-1
 garden scene 74-5
 lilies 63
 multi-coloured background
 76-7
 painting *in situ* 70-5
 painting spontaneously 63,
 64-5
 poppies with tinted
 background 78-9
 poppy field 72-3
 rose 65
 snowdrops 67
 spring flowers and cherries
 90-1
 traditional approach 62
 white flowers 66-7
 white and coloured flowers
 combined 68-9
 see also foliage
foliage 15, 38, 40-1, 75, 81
fruit 80, 81, 84-5

G

glass
 glass tumbler 86
 plain and coloured 86-7
 water in a glass container
 56, 86

glazing 6, 12, 32, 34, 35, 36, 58,
 77
greens 40, 42, 64
greys 28, 29, 33, 82

H

hard edges 35, 83
highlights 82
 softening 86
Hooker's green 8, 40, 64

I

Indian ink 11, 14

L

landscape 26-7
landscape painters 8
leaves *see* foliage
light, direction of 80, 81
light to dark, working from 38,
 43 , 74-5
light, transient 43
lights and darks *see* tones

M

masking fluid 11, 13, 14, 16, 83
masking out 13
materials and equipment 8-11
 brushes 9-10
 drawing board 10
 masking fluid 11
 outdoor painting
 equipment 11
 paints 8-9
 palette 10
 paper 10

pencils 10-11
pens 11
sponges 11
tissues 11
monestial blue 14

N
negative painting 50, 70
'oriental' style of brushwork 44

O
outdoor painting equipment 11
outdoors, painting 31, 52
overpainting 77

P
paints 8-9
 artists' quality 8
 colour permanence 8, 33
 grainy paints 14, 82, 83
 ready-assembled selections 8
 reds/yellows/ blues 8
 students' quality 8
 tubes and pans 8-9
palette 10
pans (half and full) 9
paper 10
 loose sheets 10
 stretching 10
 surfaces 10
 weights 10
pen and ink 14
pencils 10-11, 24
pens 11
permanent rose 8, 20, 29, 64
photographs, painting from 47
pots 82
primary colours 20, 21

R
raw sienna 21, 33
reds 8
resist methods 13
rose madder 40, 64, 87

S
sandpaper 13
shadows 80
shoes 88-9
simple objects
 inorganic 82-3
 organic 80-1
skies 20, 32-7
 clouds 32, 33, 34
space and distance, creating
 20-1, 22-3
spattering 14
sponges 11, 13
staining and non-staining
 colours 33, 36, 64, 83
still life 80-91
sunrise 34
sunset 34
sunshine 30-1

T
techniques 12-19
texturing techniques 14, 82
tissues 11, 13
tones 24-31, 58
trees and shrubs 38-45
 foliage 15, 38, 40-1
 trees in changing light 43
 trees in the park 42
 trees in winter 44-5
 trees without foliage 39
tubes 8-9

U
ultramarine 14, 21, 29, 33

V
'vanishing point' 46
viridian 29, 42, 64, 87

W
wash 12, 58, 74
water 54-61
 broken light effect 55

colour in 56
distant water 58
mirror-image reflection 54
moving and still 54, 60-1
surface movement 54
tonal relationships 57
water in a glass container
 56, 86
waves 59
waves 59
wet-in-wet 12, 32, 36
white 8
Winsor blue 33, 36, 87
Winsor purple 8, 21, 64
working fast 17

Y
yellow ochre 20, 33
yellows 8, 87

LIST OF SUPPLIERS

Suppliers with free mail-order catalogs:

Daniel Smith Inc.
4150 First Avenue South
Seattle, WA 98134
Toll-free: (800) 426-6740

The Italian Art Store
84 Maple Avenue
Morristown, NJ 07960
Toll-free: (800) 643-6440

The Jerry's Catalog
Jerry's Artarama
P.O. Box 58638J
Raleigh, NC 27658
Toll-free: (800) U-ARTIST

New York Central Art Supply Co.
62 Third Avenue
New York, NY 10003
Retail store: (212) 473-7705
Telephone orders:
In New York State: (212) 477-0400
Elsewhere, toll-free: (800) 950-6111

Pearl Paint
308 Canal Street
New York, NY 10013
In New York State: (212) 431-7932
Elsewhere, toll-free: (800) 221-6845

Utrecht Art & Drafting Supplies
33 Thirty-Fifth Street
Brooklyn, NY 11232
In New York State: (718) 768-2525
Elsewhere, toll-free: (800) 223-9132